PERSPECTIVE DRAWING AND APPLICATIONS

Second Edition

CHARLES A. O'CONNOR JR.

THOMAS J. KIER

DAVID B. BURGHY

Prentice Hall
Upper Saddle River, New Jersey 07458

Library of Congress Cataloging-in-Publication Data

O'Connor, Charles A.,

 Perspective drawing and applications / Charles A. O'Connor, Jr.
Thomas J. Kier, David B. Burghy. -0 - 2nd ed.
 p. cm
 Includes bibliographical references and index.
 ISBN 0-13-633025-8
 1. Perspective. 2. Drawing–Technique. I. Kier, Thomas J.
II. Burghy, David B. III. Title
NC750.036 1998
742–dc21 97-33980
 CIP

Production Team: Charles A O'Connor Jr.
 David B. Burghy
 Thomas J. Kier
 Jeff Link

Cover Design: Thomas J. Kier
Cover Page: David B. Burghy

Publisher: Bud Therien
Assistant Editor: Marion Gottlieb
Production Editor: Jean Lapidus
Prepress and Manufacturing Buyer: Bob Anderson
Cover Layout: Bruce Kenselaar

This book was printed and bound by Courier Companies, Inc.

 © 1998, 1985 by Prentice-Hall, Inc.
Simon & Schuster/A Viacom Company
Upper Saddle River, New Jersey 07458

Printed in the United States of America
10 9 8 7 6 5 4 3 2 1

ISBN 0-13-633025-8

PRENTICE-HALL INTERNATIONAL (UK) LIMITED, *London*
PRENTICE-HALL OF AUSTRALIA PTY. LIMITED, *Sydney*
PRENTICE-HALL CANADA INC., *Toronto*
PRENTICE-HALL HISANOAMERICANA, S.A. *Mexico*
PRENTICE-HALL OF INDIA PRIVATE LIMITED, *New Delhi*
PRENTICE-HALL OF JAPAN, INC., *Tokyo*
SIMON & SCHUSTER ASIA PTE. LTD., *Singapore*
EDITORA PRENTICE-HALL DO BRASIL, LTDA., *Rio de Janeiro*

TABLE OF CONTENTS

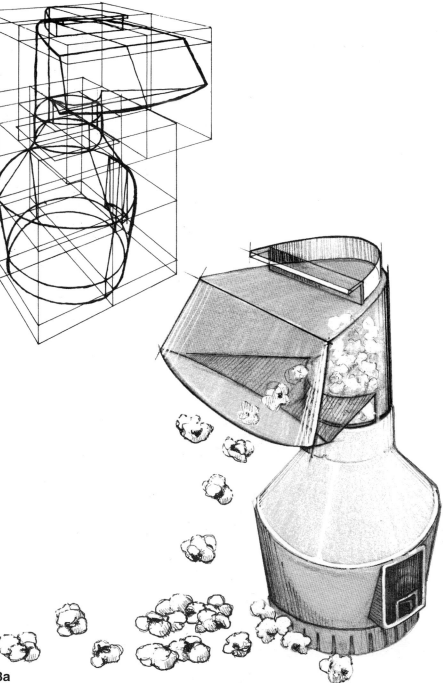

Figure 3a

The two views of the popcorn popper illustrate that the interpretation of a three dimensional form is greatly assisted by imagining it to be transparent and drawing through the object. The ability to rotate and draw the subject from different angles while maintaining consistency of scale and proportion is one measure of perspective control.

Figure 3a

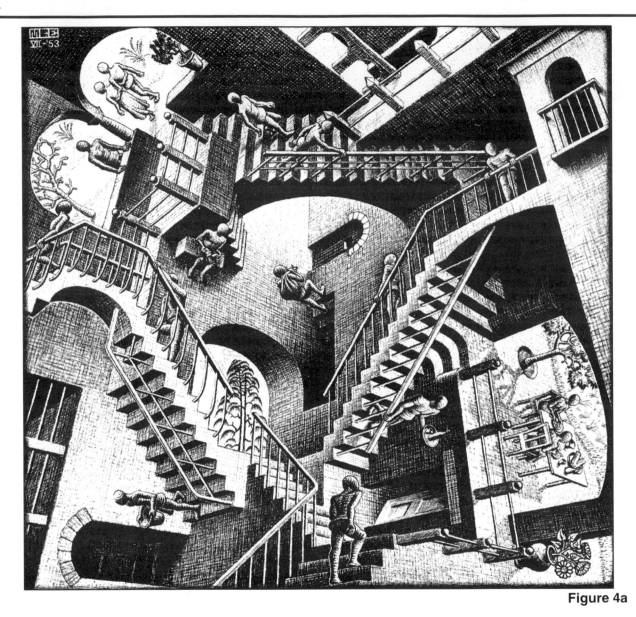

Figure 4a

This book would not have been possible without the invaluable help of countless individuals.

I would like to thank members of the faculty and staff of the Columbus College of Art and Design for their suggestions and assistance in publishing the text, particularly President Canzani for his foresight and confidence in me. Thank you to the artists, designers, publishers and students who provide many of the illustrations. (See Illustration Credits on page 96.)

I am most grateful for my friends and family who assisted with the preparation and editing of the text, especially my wife Carol for her encouragement, patience, and love. Special credit must go to all of my former students. Their interest and enthusiasm have been my motivation to complete this book.
Charles O'Connor

THE SECOND EDITION
I wish to thank my family and friends who have provided support and encouragement throughout the preparation of this second edition. In addition, I wish to recognize the motivating influence of my students, past and present. Their eagerness to learn and enthusiasm for creative endeavor has served as a driving force in the revision of this book.
Thomas J. Kier

My thanks must initially go to my parents. Without their hard work, I would not have the education that made it possible for my name to be on this book. There are also the teachers; Rick Oberdick, who helped a high school student prepare a scholarship winning portfolio. To Jim Orr, whose enthusiasm and instruction throughout college helped to refine my drawing skills. To the many instructors who provided guidance throughout my career. A special thanks goes to my wife Kimberly who, for the first year of our marriage, has endured my late nights and early mornings at my drawing board and computer to make this second edition a reality.
David B. Burghy

Figure 4a
Creative manipulation of perspective in this drawing by M. C. Escher, a master of perspective control, illustrates a basic concept. The illusion of space and distance is dependent on the viewer's interpretation. In this drawing traditional perspective theory is abandoned and conflicting spatial clues create a juxtaposition of three simultaneous realities. Rotate the page and your conception of what is horizontal and what is vertical will change.

CONCEPT

This book has two primary objectives. First, it is designed to be used as an instructional aid in drawing courses that emphasize perspective drawing principles. Secondly, it is intended to be used as a reference handbook.

An attempt has been made to present the material in a logical sequence for study. The format presented has resulted from the development of a Structural Drawing course at the Columbus College of Art and Design.

CONTENT

The text explains basic perspective fundamentals required for freehand perspective drawing. In addition, it includes the technical principles of perspective required to lay out precise perspective constructions.

In an effort to keep the text brief and concise, the figures contain illustrations and diagrams that are most important and should be studied carefully. Unfortunately, the printed media does not allow for easily depicting the sequential development of a textbook drawing. As a result, some of the figures are necessarily complex. Consequently, try to analyze each illustration for its step by step development. Doing so will greatly assist in clarifying the perspective principles to which the drawing relates.

All figures are identified according to the page on which they appear with an alphabetical suffix. As an example the first and second figures on page seventeen are identified Figure 17a and 17b respectively. In addition, all text relating directly to a figure appears with the corresponding figure.

The illustrations created especially for this text have been supplemented with examples by students and professionals from many fields. These examples include advertisements, illustrations, graphic prints, and renderings. Beginning on page 80 is a portfolio of perspective examples that illustrate the great diversity of applied perspective principles.

Figure 5a

Several perspective concepts are used in this abstraction to achieve pictorial space. The illusion of space is created with flat shapes and value contrast. Diminishing sizes and converging lines lead the eye back into the center of the composition. These are a few of the topics that have been considered in this perspective drawing text.

TO THE SERIOUS STUDENT

The theory of perspective is simple to learn, but relatively insignificant to the importance of "seeing." You must become sensitive to the spatial qualities possible on the picture plane. Whether photographic realism or spatial abstraction is intended, some aspects of perspective will apply.

At times you may wish to precisely adhere to the laws of perspective. In other drawings you might intentionally violate the "rules" to achieve a desired effect. Remember that the laws of perspective cannot be effectively manipulated without first understanding them. Creative graphic expression requires a firm foundation in perspective.

No text can be a substitute for experience. To fully realize the potentials of perspective, you must become totally involved. Practice drawing incessantly, thank God for your inherent talents and strive to do your very best whenever you draw.
Charles O'Connor

CONCERNING THE SECOND EDITION

As creative pursuits continue to embrace the ever present influences of developing technology, it has become even more apparent that creative design and visual expression must not be abandoned. Drawing and visualization skills though adaptive to the new medium must not be forsaken in our enthusiasm for new technologies.

The visual characteristics of computer imagery impact graphic expression, enforcing the need for the artist to remain creative and expressive. The principles of perspective drawing continue to provide a firm foundation for visualization and spatial expression whether it be with stylus, computer mouse or a ball point pen. It is the task of the serious art student to develop and apply these principles within the rapidly changing fields of artistic expression.
Thomas J. Kier

Drawing is communication - taking an idea, known only to the thinker, and transferring it to paper as an image to be shared with others. Pick up a pencil, visualize an idea and let creativity flow through your arm onto some paper.
David B. Burghy

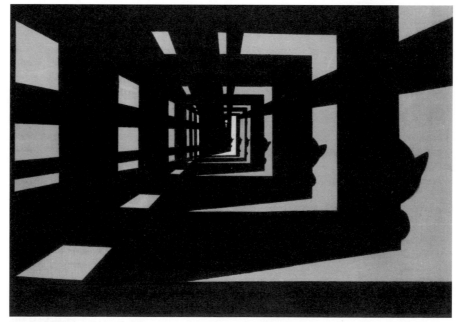

Figure 5a

LINEAR PERSPECTIVE

Linear perspective is a designer's tool; it enables the artist to represent three dimensional reality on a flat surface.

Perspective drawing is based on the laws of optics. If you have ever taken a photograph you are already familiar with the basic principles of linear perspective. Like a camera, a perspective drawing can create an image of an object as it seems to appear to the eye. But no drawing or photograph can quite duplicate visual perception. Our eyes are constantly moving, changing their focus of attention. What we "see" is affected by elements of time, motion, our experiences, emotions and physiological makeup. The photograph and perspective drawing objectively represent the scene as it appears with one eye from a fixed point of view at a given moment in time.

STRUCTURE

Before you can draw anything you must KNOW its structure. Be it the anatomy of a figure or the blueprint of a house, familiarize yourself with the structure of the subject before you attempt to draw it. Structure refers to the underlying forms, be they organic or geometric, that make up the whole of the subject. The simplification of the object into simpler, more easily drawn forms is the essence of applied structural drawing. For this reason many of the objects illustrated in the text appear transparent. Imagine the forms you draw to be the same. Lightly retain the hidden lines in your drawings. Visualizing the hidden sides of the object will help capture a sense of volume in your drawings.

Many of the illustrations throughout the text are based on drawings of cubes. The cube can be used as a basic unit of measure and expanded or divided into a wide variety of other shapes. It is for this reason that the cube is the base structural unit used for construction throughout the text.

COMMUNICATION

Drawing is communication. The mechanics of perspective are only guidelines to assist you in developing a sense of depth in your drawings. Strive to develop an ability to critically observe reality and drawing. Always check a drawing in process to make certain it looks right. The efficient representation of form in space requires a focused coordination of observation, theory, imagination, and endless practice. Lastly, you must love to draw - then learning is a joy.

Figure 6a

This diagram shows the analogy between the principles of perspective drawing and the camera. The picture plane is like the photographic film on which the image of the object is projected. The station point in perspective is the same as the lens of the camera; both represent the point from which the object is "seen."

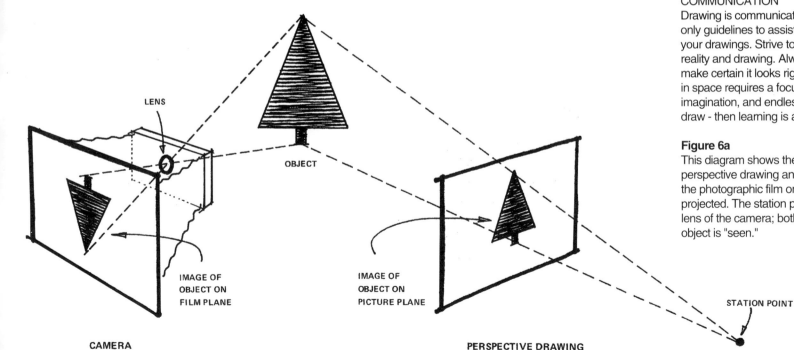

LENS

OBJECT

IMAGE OF
OBJECT ON
FILM PLANE

IMAGE OF
OBJECT ON
PICTURE PLANE

STATION POINT

CAMERA

PERSPECTIVE DRAWING

Figure 6a

EXERCISES
The relevance of this book to individual endeavors will increase with the completion of the exercises and gathering of additional reference materials.

Throughout the text there are exercises that are intended to supplement the reading of the book. These assignments are suggested activities which provide a "hands-on" experience relative to the subject. They are designed to reinforce concepts described in the text.

In addition to the exercises, there are step by step procedures included for many of the drawings throughout the book. These may be completed as exercises or critically analyzed for process. All completed exercises, notes and other collected reference materials should be kept for future reference.

EQUIPMENT AND MATERIALS
The following equipment and materials are needed to complete drawing exercises described within this text.
18" X 24" drawing board
11" X 14" drawing paper
Tracing paper
45° and 30°/60° plastic triangles
30" T-square
18" metal ruler
Masking tape
2H and #2 pencils
Matt knife
Kneaded eraser
White plastic eraser

The following are recommended supplies:
Colored pencils
Grease pencil or marker
Architectural scale
Pencil sharpener
Dry cleaning pad
Dusting brush
Spray fixative

Remember that well kept equipment is usually evident in the quality of presentation.

Figure 7a

VOCABULARY

Before discussing the fundamentals of linear perspective, it is necessary to become familiar with some of the terms that will be used. They are stated here to clarify their use in the text.

Essentially, these terms describe the methods by which the illusion of depth is achieved in a drawing. You have probably been utilizing many of the following principles in your drawings without being aware of them.

STATION POINT

The station point is either the actual or imagined location of the observer while drawing the picture. Based on the assumption in perspective that the artist's direction of sight does not change during the making of the picture, the station point cannot be moved during the construction of a drawing.

EYE LEVEL

The eye level always represents the height of the station point in a drawing. As the height of the artist's eye changes, so does the eye level of the drawing. Eye level is synonymous with HORIZON which is the line in reality on which earth and sky seem to meet. The eye level is an important reference line in every perspective drawing. The horizon may be blocked from view by tall buildings or it could occur beyond the limits of the page. Regardless, in every perspective drawing there exists an eye level (horizon) which appears as a horizontal line drawn across the picture plane.

NORMAL EYE LEVEL

Normal eye level is based on average human eye level. For purposes of simplicity, normal eye level has been rounded off to equal five feet throughout the text.

SUBJECT

The subject is the theme of the drawing. The subject matter refers to the figures or objects represented in the picture.

PICTURE PLANE

Theoretically, the picture plane is an imaginary, transparent flat surface, infinite in size, on which the drawing is made. The picture plane is located between the subject and the station point.

FRAME OF REFERENCE

The frame of reference is the limit of the composition on the sheet of paper or the canvas which contains the drawing. It represents the picture plane.

CONE OF VISION

The cone of vision represents the limited area which can be clearly seen at any one time. It can be visualized as an imaginary cone with the viewer's eye at the point of the cone. The maximum angle of vision or limit of the cone of vision is approximately 45° to 60°. Trying to draw objects beyond the cone of vision results in pronounced distortion.

CENTRAL RAY OF VISION

This imaginary line of sight is located at the cone of vision's center. It extends from the station point to the subject. The central ray of vision is always perpendicular to the picture plane.

GROUND LINE

The ground line represents the intersection of the picture plane and the surface of the ground or the ground plane. The ground line is always drawn parallel to the eye level.

MEASURING LINE

Measuring lines are used for direct scale measurements in a drawing. These lines must be parallel to the picture plane so as not to be foreshortened. For example, the GROUND LINE may be used as a measuring line.

Figure 8a

The terms defined on this page are illustrated in this drawing which shows the relationship between the STATION POINT, PICTURE PLANE, and SUBJECT. The figure at the station point is looking through the picture plane at the subject, a large cube. The image of the subject is projected toward the station point onto the picture plane resulting in the perspective drawing of the subject within the frame of reference.

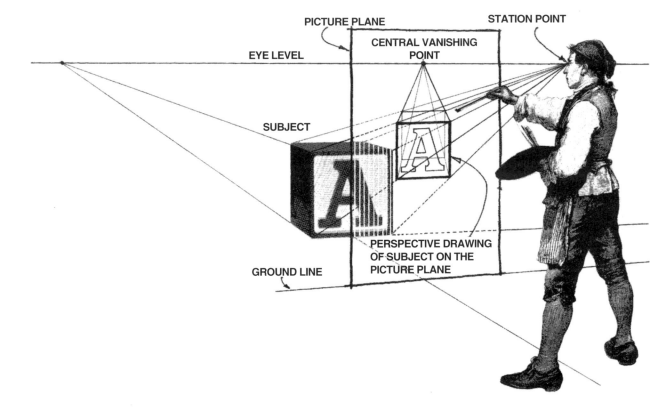

Figure 8a

SCALE

Scale is the actual size of the drawing in relation to the size of the subject in reality. A matchbox can be easily drawn full size, but a full size drawing of a house is seldom feasible. Assume that the house is actually ten feet high and it is represented in a drawing with a ten inch line. The scale of this drawing would be: one inch equals one foot or (1"=1'). In other words, every inch on the picture plane represents one foot in reality.

Generally, the scale used in a drawing depends on the size of the subject in reality and how large you wish your drawing to be. As stated earlier, some objects can be drawn smaller like a house; however a drawing may be made larger than full size. For example, an advertisement may use a full page drawing of a tiny computer chip to promote the sale of a new product.

Exercise:

A drawing completed on a sheet of acetate can be used to demonstrate how the PICTURE PLANE works. To do this exercise you will need a sheet of acetate, tape and a marker suitable for drawing on acetate. Tape the acetate to a window. As a subject, choose a stationary object which can be seen from the window. A simple form consisting of straight lines would be a good subject. Try to select a view that will include at least one vanishing point that will fall on the acetate.

Procedure:

1. Stand about two feet from the window and close one eye. Face the window with your line of sight (CENTRAL RAY OF VISION) perpendicular to the acetate.
2. Draw a horizontal line across the acetate at the height of your eye. This is the EYE LEVEL, label it EL.
3. Carefully, without moving your eye (STATION POINT), trace the outline of the subject as it appears to you onto the acetate (PICTURE PLANE).
4. After completing the drawing, locate the VANISHING POINTs in the drawing by extending parallel receding lines back until they meet the eye level forming a common point, label it VP.

Note:
 It is not unusual for some of the vanishing points to be beyond the edge of the acetate sheet or FRAME OF REFERENCE.

This exercise demonstrates the theory of perspective drawing. Obviously this procedure is not very practical for regular use. However, the same principles apply when a sheet of paper instead of the acetate is used to represent the picture plane.

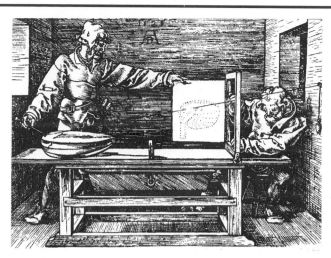

Figure 9a

Figure 9a

"Perspective" by Albrecht Durer, 1547. This print appeared in a book on scientific perspective written by Durer. It is a device for projecting correctly foreshortened pictures onto a picture plane. The lute is the subject, the hinged panel and frames represent the picture plane and the hook on the wall locates the station point.

Figures 9b

In reality, all of the blocks in these illustrations are two inches high. The scale is measured along the front vertical which is assumed to be on the picture plane. Each illustration is a different scale.

The top block is the smallest scale shown at one eighth scale. Each one eighth of an inch along the front vertical represents one inch (1/8"=1"). Because the block is two inches high in reality, the illustration measures two eighths or one fourth of an inch high. A much larger object could be represented on the page using this scale.

The bottom block is full scale because the front vertical represents two inches and measures the same. Every inch along the vertical represents one inch in reality (1"=1").

Note:
 When dimensioning a drawing always show the size being represented. When indicating scale of a drawing the size of the drawing is given first followed by the size represented. For example one inch on the drawing equals one foot of reality is shown as 1"=1'.

1/8"=1" (one eighth scale)

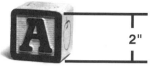

1/4"=1" (one quarter scale)

2"

1/2"=1" (one half scale)

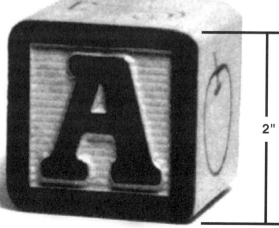

Figure 9b

2"

1"=1" (full scale)

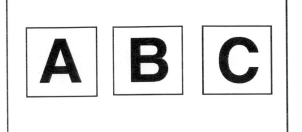

Figure 10a

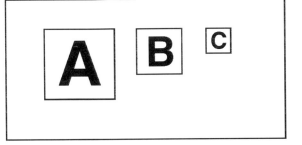

Figure 10b

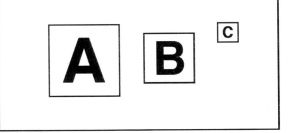

Figure 10c

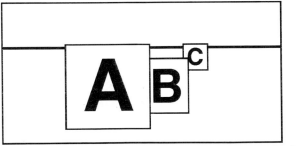

Figure 10d

SIZE

Size is the most basic element of perspective perception. Everyone knows that as an object recedes from the observer it appears to become smaller, or diminish in size. In our daily experiences we judge distance by the relative size of familiar objects.

To demonstrate, hold a ruler vertically at arm's length and observe a person at some distance walking toward you. Notice how his height appears to increase as he moves closer to you, the station point.

POSITION

In reality, objects below our eye level appear to move lower on the picture plane the closer they are to the observer. Therefore, in a drawing, objects placed lowest on the page tend to appear to be in the foreground. There are obvious exceptions (such as objects above eye level), but vertical location of elements on the picture plane does imply a certain spatial relationship.

OVERLAP

Overlap is another simple technique that defines which object is forward of another. Without utilizing any other aspects of perspective, simply placing one object partially in front of another generates a sense of depth and spatial order to the composition.

These five illustrations show how SIZE, POSITION and OVERLAP combine to affect the apparent depth of the picture. These examples purposefully use shapes that are two dimensional so that no receding lines influence our perceptions of depth. The illusion of depth and spatial order work because you associate them with your own observations of the environment.

Figure 10a. The size and position of the three squares limits the space in which they exist. They appear to be a consistent distance from the observer.

Figure 10b. Here size and position are used to give the illusion that the larger square is in the foreground while the smaller squares are becoming progressively farther away.

Figure 10c. By altering the position of the squares the illusion of spatial order is greatly enhanced. The squares appear to be on a ground plane at varying distances from the viewer.

Figure 10d. Finally the squares are overlapped. Placing one object partially in front of another generates a sense of depth and spatial order. The additional use of a horizontal line implies the existence of a distant horizon. Here we begin to realize the bonds between perspective drawing, visual perception and abstraction.

Figure 10e. This side view of the perceived composition diagrams why objects appear larger and lower on the picture plane as they become closer to the observer.

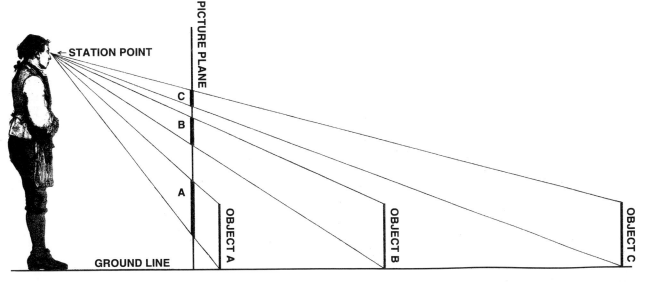

Figure 10e

VANISHING POINT 11B CENTRAL VANISHING POINT 11A VANISHING POINT 11C EYE LEVEL

Figure 11a **Figure 11b** **Figure 11c**

FORESHORTENING
Foreshortening is the apparent diminishing of the length of some lines to create the illusion of depth. Lines or planes appear progressively shorter as their angle to the picture plane increases. Therefore, only lines and planes which are parallel to the picture plane show their true shape.

CONVERGENCE
Lines that in reality are parallel to each other appear in perspective to come together or converge as they recede from the observer. The classic example is the railroad tracks converging at the vanishing point on the distant horizon.

VANISHING POINT
A vanishing point is where two or more parallel receding lines appear to converge. The vanishing points for all horizontal parallel receding lines are always on the eye level.

CENTRAL VANISHING POINT
The central vanishing point is the vanishing point for all lines perpendicular to the picture plane. A central vanishing point is used in one point perspective. It is on the eye level, directly in front of the observer's station point. In simplest terms it is where the observer is looking.

AUXILIARY VANISHING POINT
Auxiliary vanishing points are for parallel lines on receding diagonal or inclined planes. These points are never on the eye level. (Covered in detail on page 37.)

SPECIAL VANISHING POINT
Special vanishing points are vanishing points which are established for measuring foreshortened lines or other construction purposes. (Covered in detail on page 35-36.)

VANISHING POINT THREE
Vanishing point three is the vanishing point for receding vertical lines. This occurs only in three point perspective. (Covered in detail on page 75.)

DISTORTION
No discussion of perspective terms would be complete without addressing the issue of distortion in perspective drawings. Distortion is the apparent twisting or deviation from what is perceived to be the normal shape of the subject being drawn. This distortion of form is the result of attempting to draw objects or elements of the environment that extend beyond the cone of vision. It should be noted that on occasion the use of distortion is desirable as a means of enhancing drama or exaggerating apparent scale within a composition.

Figure 11a
The surface containing the letter A is parallel to the picture plane. All edges are equal in length, however only the front surface is not foreshortened. The receding top and sides of the block converge at the central vanishing point.

Figure 11b
The surface containing the letter A is no longer parallel to the picture plane and appears foreshortened or narrower than in Figure 11a. All of the horizontal lines of the cube appear to converge toward vanishing points.

Figure 11c
As the cube rotates farther, the angle of the surface containing the letter A, to the picture plane increases and the amount of foreshortening becomes greater. The vertical edges of the surface are no longer the same length as in Figure 11a. The left edge is now farther away from the picture plane than the right edge and therefore appears smaller.

Figure 12a

This drawing reviews many of the terms previously defined. The Subject of the drawing is two cubes equal in size but at different angles to the Picture Plane and not the same distance from the Station Point.

Note that block "A" Overlaps block "B" and is therefore closer to the Picture Plane and appears larger in Size. All of the parallel horizontal receding lines Converge toward Vanishing Points on the Eye Level.

Block "A" is in Two Point Perspective, the sides Converge at Vanishing Point Left and Vanishing Point Right. Block "B" is in One Point Perspective. The surface containing the "B" is parallel to the Picture Plane and therefore has no vanishing points. The other sides of block "B" which are perpendicular to the Picture Plane are Foreshortened and appears to Converge toward the Central Vanishing Point.

All the vertical lines of the objects have remained vertical and parallel to each other. The verticals are diminishing or become shorter as they become farther away from the Picture Plane.

The dashed line outlines the Cone of Vision. The Cone of Vision is centered on the Central Ray of Vision which indicates the line of sight. If the cubes were drawn beyond the Cone of Vision they would appear Distorted.

The cubes in reality are two foot cubes; however they are drawn in Scale of three fourths inch equals one foot (3/4"=1'). This is evident by the spacing of the one foot marks that are placed on the vertical Measuring Line. Continuing up the Measuring Line on the front vertical of the cube you find the Eye Level to be five feet from the Ground Line. This means that the Station Point was at a Normal Eye Level for this drawing.

ABBREVIATIONS

For the sake of conserving space and clarity, the following abbreviations are used in the illustrations throughout the book. You should use the same abbreviations to label elements of your construction drawings.

AVP	Auxiliary Vanishing Point
COV	Cone of Vision
CRV	Central Ray of Vision
CVP	Central Vanishing Point
EL	Eye Level
GL	Ground Line
ML	Measuring Line
NEL	Normal Eye Level
PP	Picture Plane
SP	Station Point
SVP	Special Vanishing Point
S' VP	Sun's Vanishing Point
VP	Vanishing Point
VPL	Vanishing Point Left
VPR	Vanishing Point Right
VP3	Vanishing Point Three

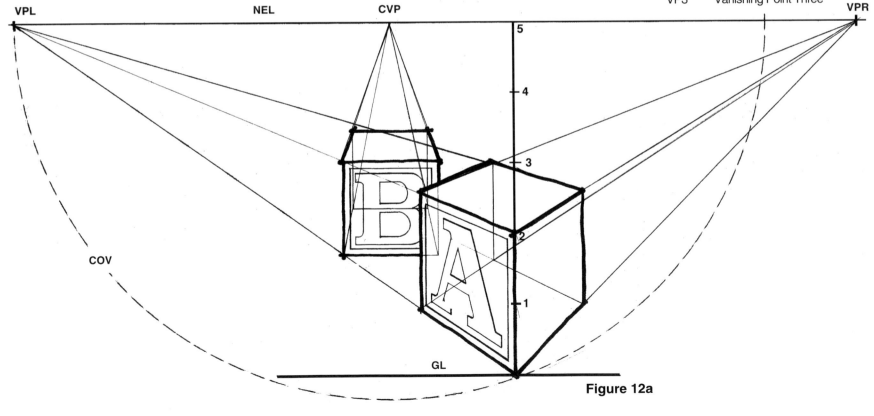

Figure 12a

LINE

Line is a basic means of communication, whether it is used to form letters in print or shapes in a drawing. The quality of the line itself can suggest depth in a drawing. The physical properties of line include length, width, value, color, texture, and character. These are controlled in part by the media and all affect the illusion of three dimensional space in a drawing.

Normally, in preliminary drawings, the lines are kept light by using a 2H or harder pencil. After the construction of the object is complete, the visible lines of the object are darkened with a soft pencil or pen. Usually lines closest to the picture plane appear the heaviest.

DETAIL, TEXTURE and PATTERN

Limiting discernible detail to objects close to the picture plane helps control the depth in a drawing. Surface textures and pattern become dense and ambiguous as their distance from the picture plane increases. The use of repetitive forms, such as geometric patterns which appear to recede into the background, assist in establishing the depth of a picture. Textures must be consistent with the scale and foreshortening of the surfaces on which they appear.

VALUE, SHADE and SHADOW

Light is an essential element for any visual perception. The contrast of light and dark in a drawing gives form to the objects. Chiaroscuro is the modulation of tonal qualities according to specific direction of light. This technique of controlling the range of dark and light or value range, is consistent with reality and therefore is an effective means of achieving pictorial space.

Shade is comparative darkness caused by the surface being turned away from the light. Shadow is cast by an object intercepting the light rays from surfaces facing the light. The amount of value contrast can heighten the illusion of space. The shade and shadows on closer objects are usually more intense, having a greater range of value contrasts than more distant objects which take on an overall neutral gray appearance. Other aspects of shade and shadow are covered in the chapter devoted to construction of shadows.

ATMOSPHERE

Atmospheric or aerial perspective achieves the effect of distance by decreasing the clarity of objects as they recede into the picture. Atmospheric haze covering distant objects causes subtle value modulation and a lessening of color intensity.

FOCUS

The camera and the human eye can only focus on a limited depth of field at any one time. As an example, when one looks at a distant object, other objects in the foreground appear out of focus. This phenomenon can be used to separate various planes of depth in a picture

COLOR

In reality color is affected by space. Consequently we interpret variations of color in a picture as space. The value, intensity, and even the hue of colored shapes change as their distance from the picture plane increases. The illusion of space through color is dependent on many variables. Color itself is relative. There are many generalizations concerning color, but the complexity of specific applications elevates the study of color beyond mere memorization of "rules."

Figure 13a

This Op-Art pattern creates a distorted spatial relationship. The forms seem to advance and recede as their width, direction and proximity change. The optical illusion takes on a spatial quality because of the viewer's interpretation. As an example, the illusion of depth is heightened when a mental association is made between the patterns and converging parallel lines in reality.

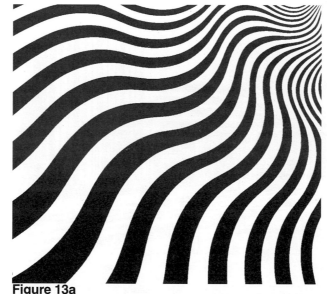

Figure 13a

Figure 13b

The perspective juxtaposition of planes in space employs many devices to achieve a spatial quality. Overlap, size, converging lines and control of value are some of the more prevalent elements used in the design. There is a consistent direction of light and a greater contrast of values in the foreground compared to the subtle gray areas deep in the picture.

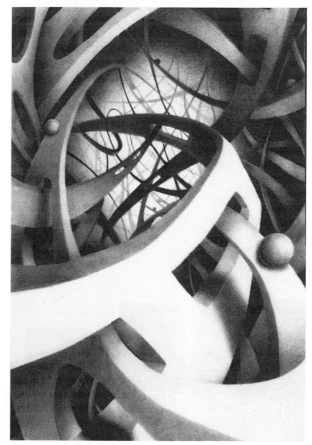

Figure 13b

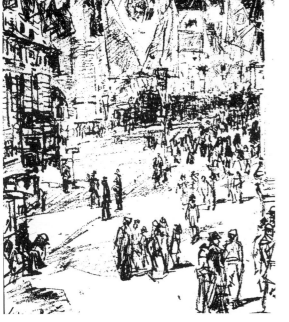

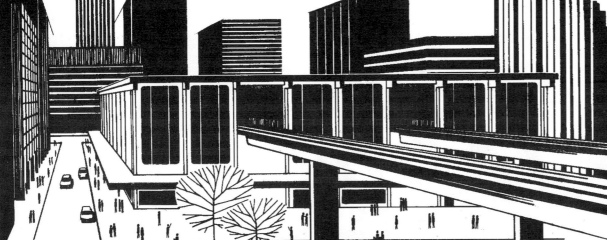

Figure 14a

Figure 14b

PRESENTATION

Most of the illustrations in the book were drawn in pencil; others were completed using a variety of media including ink, pastels, oils, acrylics, markers and computer imagery. The important factor is that technique and presentation have an effect on the depth perception of the picture. Technique varies as does the individual artist, but the technique must be appropriate to the idea. Fundamentally, attributes such as neatness, cleanliness, consistency and a general excellence in craftsmanship constitute the foundation for professional presentation.

SUMMARY

Perspective deals with the illusion of depth in the picture. Predictable spatial order requires the relationship of the station point, picture plane and subject to be governed by the mechanics of linear perspective. The spatial properties of color, value, line, and texture all contribute to the spatial illusion. The complex combinations of intuitive and analytical elements must be controlled by the artist. Each picture, realistic or abstract, offers the opportunity for a unique relationship of elements which is the essence of individualism in graphic expression.

Figures 14a, 14b and 14c
These three street scenes offer a contrast in technique, each achieving its own spatial quality.

Figure 14a uses a spontaneous line that suggests the activity and excitement of the avenue it depicts. There is an infinite variety of line weight and directions. The figures and objects become a texture of line as they move into the distance.

Figure 14b captures the character of the old buildings with a single weight of line. Architectural details, pattern and the use of transparencies contribute to the atmosphere of the scene.

Figure 14c uses straight precise lines and simple black and white forms to define the organization of this contemporary city. Entire buildings are reduced to simple geometric textures.

The above techniques express a different quality according to the demands of the artist. Within each drawing there is a consistency of approach which gives the example unity and impact.

Figure 14c

The distinction between the types of perspective is dependent on the relationship of the object and the picture plane. The types of perspective might best be defined by the example of a simple cube. In any rectangular volume, such as a cube, there are three sets of parallel lines that define the surfaces of the object. These sets of parallel lines are either parallel to or recede from the picture plane. Each set of parallel lines that recedes, requires a vanishing point.

One point perspective, two point perspective and three point perspective are so termed according to the number of primary vanishing points required to draw the object. The number of required vanishing points is determined by the angle of the cube's sides to the picture plane. An important aspect that often leads to some confusion is that in any type of perspective drawing the number of vanishing points is unlimited. Only the primary vanishing points are considered in defining the "Type of Perspective" in a drawing.

Figures 15a, 15b, and 15c
These three drawings of the same cube illustrate the three types of perspective. All of the cubes are drawn below the eye level; only their angle to the picture plane has been changed.
Figure 15a. In this One Point Perspective drawing the lines perpendicular to the picture plane recede to the central vanishing point.
Figure 15b. In the Two Point Perspective drawing, two sets of parallel lines recede and converge at vanishing points.
Figure 15c. In this Three Point Perspective drawing the picture plane has been tilted downward. All these sets of parallel lines recede from the picture plane to vanishing points.

Exercise:
To further clarify the relationship between the types of perspective, select a photographic example of each type of perspective. Magazines and newspapers offer a good source of potential photographic examples.

Procedure:
1. Neatly cut a photographic example of each type of perspective from selected sources.
2. Mount each photograph neatly on a piece of 11"X14" white drawing paper.
3. Identify the type of perspective and locate the eye level and vanishing points in each photograph. You may draw on the photograph or use an overlay of tracing paper.

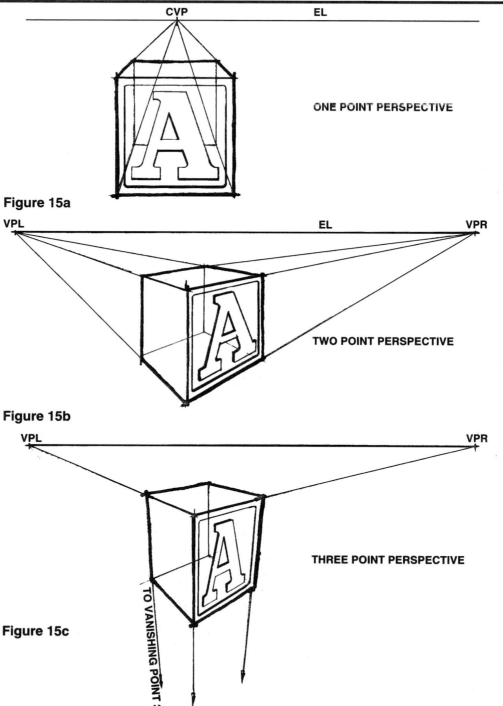

ONE POINT PERSPECTIVE

Figure 15a

TWO POINT PERSPECTIVE

Figure 15b

THREE POINT PERSPECTIVE

Figure 15c

A drawing is in one point perspective when the picture plane is vertical and parallel to one side of the object. One point perspective has limited use since we seldom see objects from this angle. Often one point perspective is used to emphasize one elevation as in a room or building facade. Advantages of one point perspective are simplicity, speed and accuracy. Measurement is easy and efficient. For these reasons, one point perspective is discussed first in this text.

Figure 16a
These three blocks all have their front and back faces parallel to the picture plane. These surfaces appear to be undistorted squares. Because the blocks are parallel to each other, all of the receding horizontal lines converge at the same vanishing point on the eye level. These horizontal lines are perpendicular to the picture plane and therefore converge at the central vanishing point. Block "A" is above the eye level and the bottom surface is visible. Block "B" is below eye level and the top surface is shown. Block "C" is on the eye level, neither the top or bottom surface are visible.

Figure 16b
This cartoon employs the use of one point perspective in a dramatic fashion. The buildings are rectangular objects with their ends parallel to the picture plane. All of the receding lines of the buildings converge at the central vanishing point. (An exception is the detonator which is in two point perspective.) The extreme distortion which occurs near the edges of the image might be objectionable in some other illustration. Here however, it adds to the impact of the idea and suggests what is about to happen in the illustration.

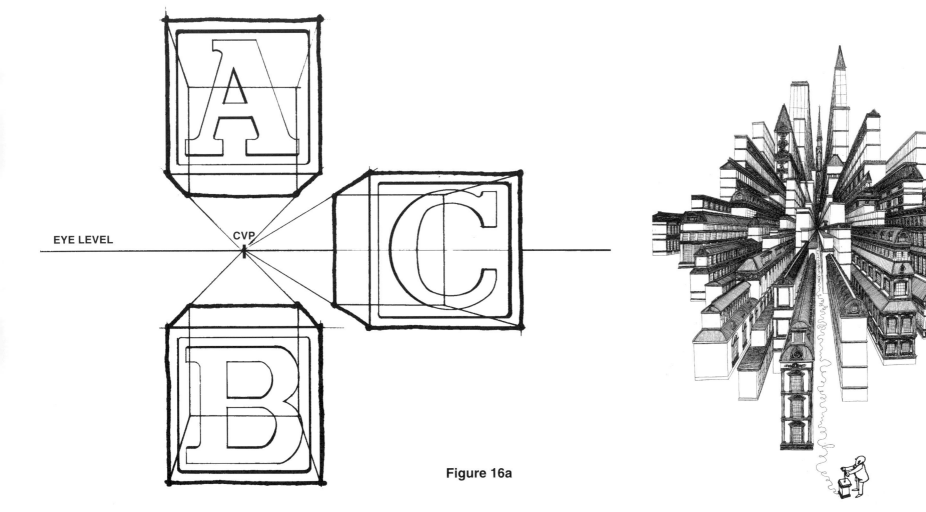

Figure 16a

Figure 16b

Two point perspective occurs when the picture plane is vertical but not parallel to any of the sides of the rectangular object. Only the vertical lines of the object are parallel to the picture plane. This parallel set of lines does not recede from the picture plane and as a result does not converge to a vanishing point. Two point perspective is the type of perspective that is most commonly used in drawings. As such it has been used throughout the text to explain principles that are often relevant to all types of perspective.

Figure 17a

All of the vertical lines are parallel to the picture plane. No horizontal lines are parallel to the picture plane; they all recede to vanishing points. The receding lines on all three cubes converge to the same two vanishing points because the cubes are parallel to each other. Vanishing point left and vanishing point right are both on the eye level because all of the receding lines are horizontal. Block "A" and Block "B" appear the same height because they are equally distant from the picture plane. Block "C" which is farther behind the picture plane appears smaller.

Figure 17b

Figure 17b

The house sits vertical but at an angle to the picture plane. All horizontal lines of the front and side of the house recede and converge to their respective vanishing points. The vertical lines of the structure remain vertical and parallel to one another and the picture plane. The use of two point perspective heightens the reality of this commonplace scene by minimizing distortion.

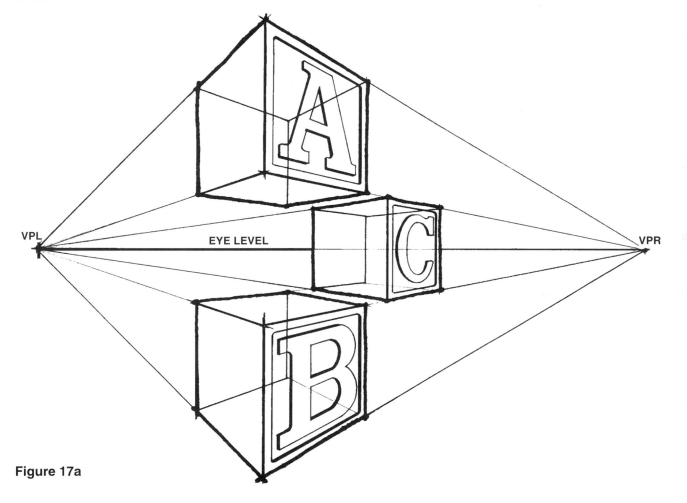

Figure 17a

In three point perspective, the picture plane is assumed to be tilted. It is no longer parallel to the vertical lines of the subject, which now appear to recede to vanishing point three. This indicates that the observer is looking up or down at an angle. Although three point perspective is the most difficult to construct, it offers the most spectacular results. It is important when drawing in three point perspective, that objects well away from the eye level are not placed beyond the cone of vision. This may result in extreme distortion of the object resulting from a station point that is too close to afford a view of the entire scene.

Figure 18a
The observer is looking down at the three blocks. The picture plane is tipped downward and therefore is not parallel to the vertical lines of the blocks. These parallel vertical lines converge at vanishing point three, located below the bottom of the page. The receding horizontal lines still converge at vanishing points on the eye level as they would in two point perspective. The front vertical of Block "B" appears shorter than Block "A" because the picture plane is tipped and therefore Block "B" is farther away. In addition, Block "B" is located at the outer edge of the cone of vision. As a result, it is somewhat distorted.

Figure 18b
This dramatic aerial view of the building seems to be drawn from a station point high in the air. The picture plane is tilted at a very steep angle resulting in the extreme convergence of the receding verticals. Vanishing point three occurs within the composition, indicated by a small dot located just below the front corner of the sidewalk. The foreshortening of the verticals emphasizes the height of the building. This is an effect impossible to achieve without three point perspective.

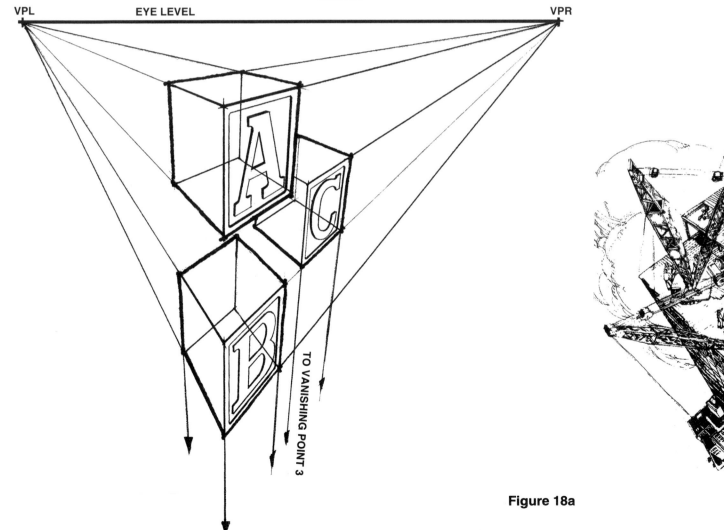

Figure 18a

Figure 18b

One point perspective is also known as parallel or central perspective. These alternate titles are derived from some of the following characteristics of one point perspective.

A rectangular object drawn in one point perspective always has front and back surfaces parallel to the picture plane. The surfaces that are parallel to the picture plane are not distorted and appear as proportional rectangles in the picture. When such a surface is against the picture plane, measurements can be made using a ruler or scale. Any lines perpendicular to the picture plane always recede and converge at the central vanishing point.

Exercise:

Use Figure 19a as a guide to construct a one point cube.
Use 11"X14" drawing paper or larger.
Use a scale of 1/2 inch equals 1 foot.
Establish a normal eye level of five feet.
Station point is seven feet from the picture plane.
Construct a three foot cube.
Position the front of the cube against the picture plane.

Procedure:

1. Draw a horizontal line near the center of the page to represent the eye level (EL).
2. Measure down five feet in scale to establish the ground line (GL).
3. Locate the central vanishing point (CVP) on the eye level, centered on the page.
4. Locate the two special vanishing points (SVP) the same distance from the central vanishing point as the station point is from the picture plane. These serve as the vanishing points for all receding lines that are 45° to the picture plane, including the diagonals for the top and bottom of the cube.
5. Construct the front surface of the cube by drawing a three foot square with its base on the ground line.
6. From the corners of the square, project the receding lines of the cube back to the central vanishing point.
7. Starting from a lower front corner of the square, draw a line to the opposite special vanishing point. Where this line crosses the bottom receding edge of the cube determines a back corner of the cube.
8. Beginning at the back corner, complete the back surface of the cube by drawing the horizontal and vertical edges parallel to the cube's front surface. This completes the drawing of the cube.

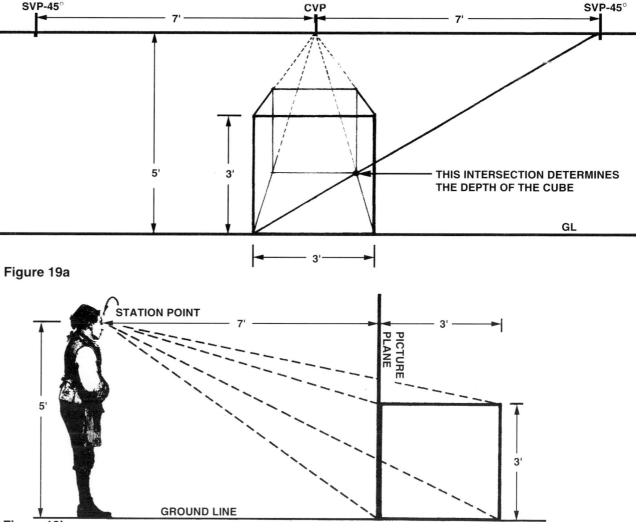

Figure 19a

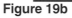

Figure 19b

Figure 19b

This drawing shows a side view of the above composition. The eye of the person in the drawing represents the station point in Figure 19a. The central ray of vision or line of sight of the observer is directed at the central vanishing point. The dashed lines indicate the projection for the corners of the cube. Note that the depth of the cube is in reality three feet. However, in Figure 19a the depth appears shorter because as the edges recede from the picture plane they are foreshortened .

Figure 20a

Figure 20b

DIAGONAL MEASUREMENT METHOD

The method described on the previous page can be used to locate any depth in perspective. Figures 20a and 20b explain the basic theory of diagonal measurement which is used throughout perspective drawing.

Figure 20a

This drawing shows three squares, the top or plan views below and the perspective views above them. Any point within a square can be reproduced in perspective through the use of the square's diagonals. The left square is the simplest example where the diagonals are used to find the center of the surface. This is true in both the plan and perspective views. Note the perspective center is not the mathematical center of the square. The middle square uses the diagonal to divide the square into nine equal spaces. The square to the right uses the diagonal of the square to locate a point that is 2 1/2 feet behind the picture plane.

In all cases, one edge of the square is parallel to the picture plane and against the ground line. Direct measurements with a ruler are made along this line. This is possible only because the line is on the picture plane. Receding lines are always foreshortened and cannot be measured with a ruler. The principles applied here are based on the fact that the diagonal of a square is always 45° to the sides and bisects the square through the opposite corner. As a result another term for this method is the "diagonal bisector method." The receding edges of the square will always represent the same length as the side which is parallel to the picture plane.

Figure 20b

This drawing is similar to Figure 19a. However the front surface of the cube has been moved back 2 feet from the picture plane. This cube is still sitting on the ground plane just behind the picture plane. This has been accomplished by constructing a smaller 2 foot square for the purpose of measuring back from the picture plane. A 45° diagonal projects from the front corner of the square to the opposite special vanishing point. The intersection of the diagonal and the opposite receding line establishes the distance back from the picture plane. The remainder of the cube is constructed as before. However care must be taken to measure the height of the cube on the picture plane. This measurement is then projected back from the picture plane toward the central vanishing point.

Ultimately, the purpose for studying perspective is to use it in pictorial compositions. To demonstrate a typical use of one point perspective, the illustrations on pages 21 and 22 show some of the developmental stages involved in the drawing of an interior composition. (Continued on page 22.)

Figures 21a, 21b and 21c

The floor plan and elevation provide the information needed to draw the room and locate the objects within it. Figure 21c shows the completed construction drawing.

Exercise:

Use the figures on pages 21 and 22 as a guide to complete this one point perspective room construction.
Use 11"X14" drawing paper or larger.
Use a scale of 1/2 inch equals 1 foot.
Establish an eye level of four feet.
Station point is nine feet from the picture plane.
Label all elements of the drawing as indicated.

Procedure:

1. Draw a rectangle representing the front wall on the picture plane, with the bottom edge on the ground line. Make the scale measurements around the rectangle.
2. Locate the eye level four feet above the ground line.
3. Locate the central vanishing point near the right wall on the eye level. This will show more of the left wall.
4. Draw receding lines from the four front corners of the room, back to the central vanishing point.
5. Establish a station point by locating a special vanishing point nine feet from the central vanishing point.
6. Project a diagonal line from the ten foot mark on the ground line to the special vanishing point. The intersection of the diagonal and the left bottom edge of the room is the back corner of the room.
7. Begin construction of the perspective floor grid. Draw receding lines from the measurements marked along the ground line, back to the central vanishing point.
8. Depth measurements for the floor grid are established where the diagonal from the ten foot mark crosses each receding grid line. Construct horizontal lines parallel to the picture plane at each intersection. Keep these within the edges of the floor.
9. Objects are positioned on the grid according to the floor plan, Figure 21a. To complete the room, close study of the drawing will reveal the construction lines needed to locate all of the objects in the room.

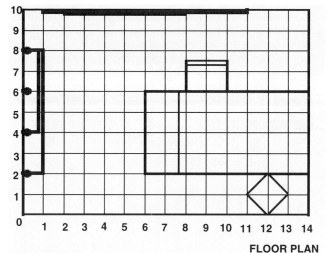

Figure 21a FLOOR PLAN

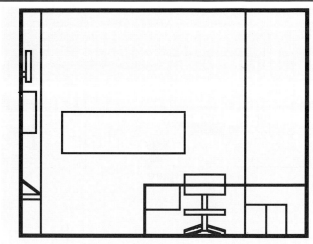

Figure 21b ELEVATION

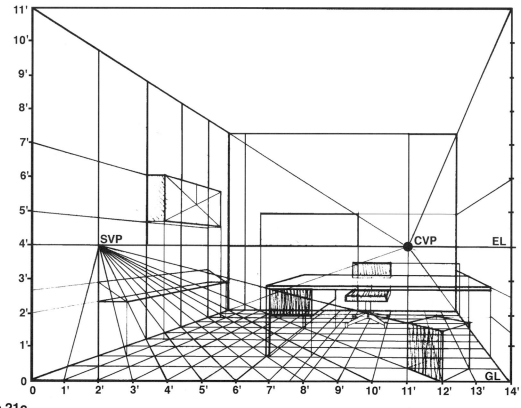

Figure 21c

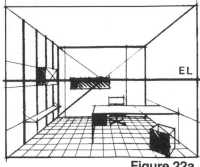

Figure 22a

Figure 22b

Figure 22c

Figure 22d

Figure 22e

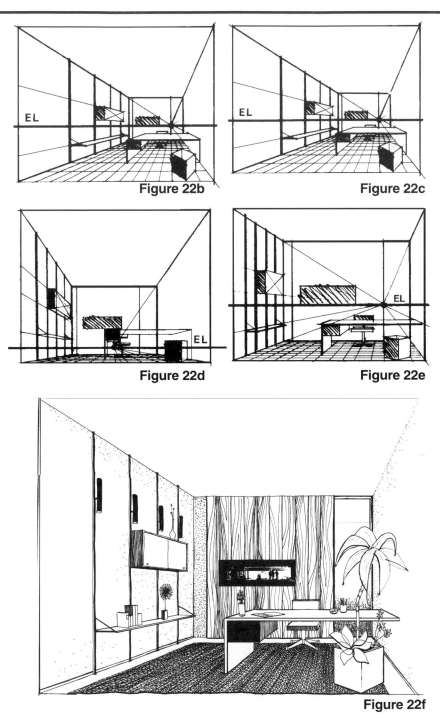

Figure 22f

THE INTERIOR COMPOSITION

The first step is to plan the room, either by compositional studies, from one's imagination or from a floor plan and elevation as shown at the top of page 21. The next concern is to decide where to place the station point and eye level in the drawing so as to show the most of the interior space. The preferred method is to complete a series of studies as shown at the top of this page. These are referred to as thumbnail sketches and aid in the selection of the a viewpoint for the composition.

From these rough thumbnail sketches, Figure 22c was selected as the view to develop as a final drawing. This view shows the more interesting left wall while depicting a strong sense of depth. A construction drawing of the interior is then laid out using the procedures described on page 21. Figure 21c shows the completed construction drawing.

The illustration is finalized either directly on the construction drawing or by using overlays. Lines of the room are darkened and details are added freehand as shown in Figure 22f.

Figure 22a is drawn from normal eye level with the central vanishing point in the very center of the room. Notice the symmetry caused by planes being equally foreshortened.
Figure 22b uses a low eye level which emphasizes the ceiling. Here the room is seen from a "worm's eye view."
Figure 22c depicts the eye level at four feet. The central vanishing point has been moved to the right, emphasizing the left wall. The composition is more dynamic than the previous two. This is the view selected for the final drawing.
Figure 22d. The station point is only four feet from the picture plane. Observe how deep the room appears. Objects drawn near the front of the room would be quite distorted because the front corners of the room are beyond the cone of vision.
Figure 22e. The station point is twenty feet from the picture plane. The room appears shallow and no distortion exists because the entire room is well within the cone of vision.

Figure 22f. The details not shown in Figure 21c have been estimated using the construction drawing as a guide. The details and technique were added by freehand drawing over the construction.

Notice that the planter in the foreground is not parallel to the picture plane. The planter has been placed at a 45° angle to the picture plane which results in the sides converging to the special vanishing points.

Figure 23a

This interior sketch demonstrates the use of one point perspective. One point perspective is a very effective tool in the exploration of interior spaces that are relatively deep. Here the use of one point perspective enhances the effect of the structural ceiling beams and provides a true sense of distance from the picture plane.

Figure 23b

This advertisement employs many principles of one point perspective. The spatial quality of this airport scene is an effective abstract application of one point perspective. This demonstrates how simplicity of one point perspective can be used to make a graphic visual statement.

Figure 23c

This sixteenth century drawing illustrates an important principle regarding the cone of vision. The squares constructed on the floor appear to become unrealistically distorted as they become farther from the central vanishing point. More of the floor has been shown than should be seen from the location of the station point. As a result the front left and right squares are beyond the cone of vision.

Exercise:

The composition shown in Figure 23a is the subject for this study of applied perspective principles. You will need tape, drawing pencils and tracing paper for use as an overlay.

Procedure:
1. Tape a sheet of tracing paper over Figure 23a.
2. Find the central vanishing point (CVP) for the lines receding from the picture plane.
3. Locate the eye level (EL) by drawing a horizontal line through the central vanishing point.
4. Determine the height of the eye level by using the human figures as a reference to scale.
5. Using this reference to scale and the established central vanishing point, add a perspective element to the composition such as a door, window or piece of furniture.

Figure 23a

Figure 23b

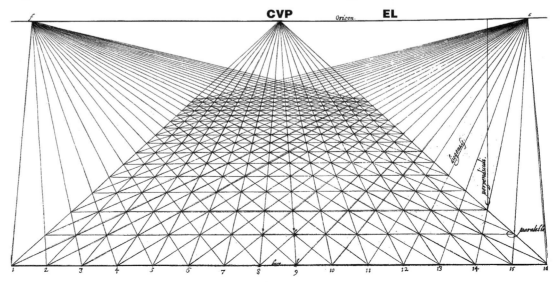

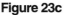

Figure 23c

One point perspective is one of the most effective methods of capturing the spatial relationships within interior spaces. This page demonstrates the application of one point perspective principles as a method of exploring and presenting interior design concepts. A common practice utilized by professionals is to begin with an initial line drawing that is based upon an established one point perspective grid. Next, through a series of overlays a finished composition can be built up which results in a presentation quality rendering. This rendering is presented to the client as a means of communicating the spatial relationships within the conceptual space.

Figure 24a

This line drawing is a conceptual sketch that has been used to explore the potential of a large grocery store design. The initial building structure was constructed as a starting underlay in one point perspective. This underlay included a grid pattern that was spaced to match the floor tiles. The grid also facilitated construction and placement of interior details.

Figure 24b

This conceptual rendering is the finished presentation drawing of the Food Market as it was presented to the client. Using the line work shown in Figure 24a as a beginning, successive overlays were used to refine the detail and structure of the space. Once the proportions and desired spatial relationship has been established the designer then adds ink, marker and pastel to achieve the desired presentation technique. This approach to developing a rendering of complex spaces is common throughout the interior and display design field.

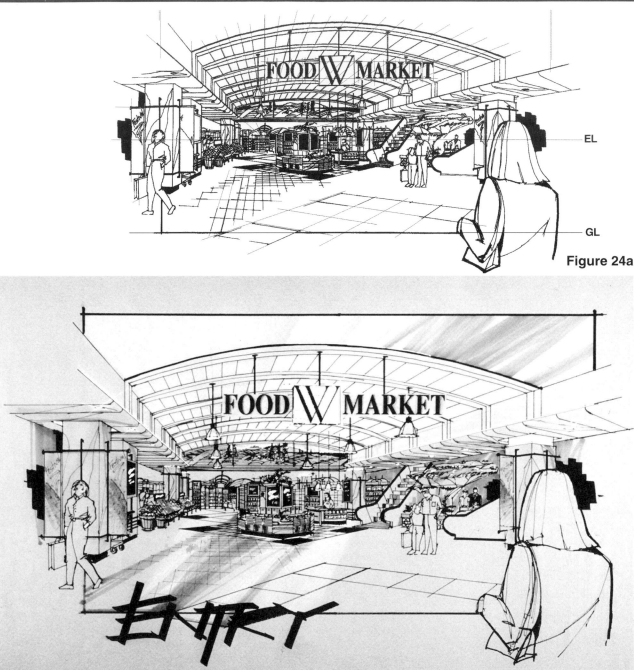

EL

GL

Figure 24a

Figure 24b

This method of construction is particularly useful for freehand drawing of circles which are near the central ray of vision. This method does not compensate for normal distortion that occurs when circles are drawn near the edge or beyond the cone of vision. In such cases the two point perspective method of construction, as shown on page 43, is recommended.

In perspective the circle becomes foreshortened and appears as an ellipse. Although ellipse guides are available, they are limited to certain sizes. Considering the endless number of objects for which a circle is an important part, seldom do the ellipse guides fit the drawing. To depict circles in perspective, practice drawing ellipses until the ability to quickly and accurately execute any size or angle of ellipse is mastered.

Exercise:
Use a cylindrical object such as a beverage can for this observational exercise.

Procedure:
1. Hold the can at arm's length in front of you so that the top is seen as a perfect circle.
2. Slowly rotate the can until the top disappears from view. Observe how the circle becomes elliptical, foreshortened until the top appears as a straight line.
3. Next hold the can vertically, the top even with your eye level so as to sight across the top of the can.
4. Slowly lower the can until it disappears beyond your cone of vision. Observe how the top of the can first appears to be a straight line, then became increasingly rounder as it moved farther from the eye level.

Figure 25a
The closer they are to the eye level, horizontal circles become increasingly more foreshortened. Note that only the minor axis changes length. The major axis of all the circles remains the same length. The further above or below the eye level the circle is drawn, the closer in length the major and minor axes become.

Figure 25b
Perspective circles also appear as part of many forms, as shown in Figure 25b. The pages of the book illustrated in Figure 25b, move through an circular arc as the pages are turned. Arches, doors and many other forms are either made of circular components or move in circular paths.

Figure 25c
This drawing of a fire extinguisher demonstrates the practical application of one point perspective circles. Here circles drawn in one point perspective provide the structure for the main cylinder and the nozzle of the fire extinguisher. Though made up almost entirely of circular forms, construction started by drawing rectangular volumes in which to construct the circles.

Note that the trigger assembly at the top of the cylinder is in two point perspective. This assembly has been rotated at a 45° angle to the picture plane thus; two vanishing points are used to draw the receding edges. This is the same principle used in Figure 22f for the planter which is in the foreground.

Figure 25b

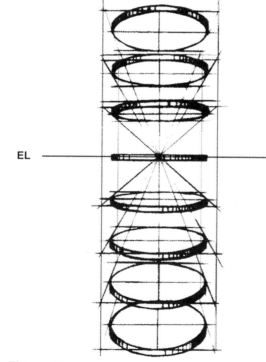

EL

Figure 25a

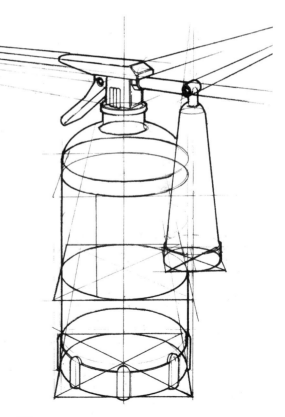

Figure 25c

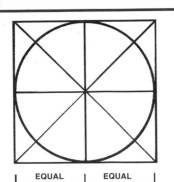

Figure 26a

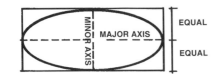

MINOR AXIS

MAJOR AXIS

EQUAL

EQUAL

Figure 26b

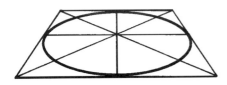

Figure 26c

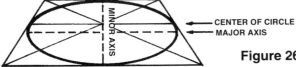

MINOR AXIS

CENTER OF CIRCLE
MAJOR AXIS

Figure 26d

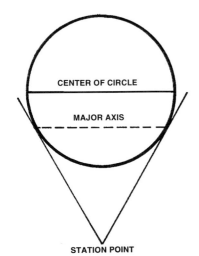

CENTER OF CIRCLE

MAJOR AXIS

STATION POINT

Figure 26e

GEOMETRIC ELLIPSES AS CIRCLES IN PERSPECTIVE
Initially the relationship between geometric ellipses and perspective circles is somewhat confusing. The confusion is compounded by the fact that geometric ellipses are often constructed to represent perspective circles. The figures on this page explain the relationship between the two.

Figure 26a
Constructing a circle in perspective can be aided by inscribing it within a square. This drawing shows the relationship of a true circle to a square. The intersection of the diagonals locates both the center of the square and the circle. The circle is tangent to or touches the middle of each side of the square.

Figure 26b
This figure gives information on the construction of geometric ellipses. Every ellipse contains two axis which are always at right angles to each other. The major axes is the widest part of the ellipse while the minor axis is the narrowest part of the ellipse. These axes bisect each other, dividing the ellipse into four equal quadrants.

Figure 26c
This drawing represents a circle in perspective placed within a foreshortened square. Actually it is the same geometric ellipse from Figure 26b. This confirms the fact that a circle in one point perspective is really a geometric ellipse. This applies to whether the circle is drawn horizontally, vertically or diagonally. For this reason the major and minor axes of the geometric ellipse are used as construction lines for the drawing of a perspective circle.

Figure 26d
When Figures 26b and 26c are overlaid, the difference between a perspective circle and a geometric ellipse can be seen. The widest part of the geometric ellipse, the major axis, falls in front of the perspective center of the square. This is the result of foreshortening. The geometric major axis is always at the midpoint of the geometric minor axis.

Figure 26e
The reason the perspective circle's diameter does not appear to be the widest part of the ellipse is explained by this top view. The widest part or apparent center of the circle as seen from the station point is not the circle's diameter. It is where the lines drawn from the station point are tangent to the circle. In other words we cannot see half way around a circular object; consequentially the geometric major axis is always in front of the perspective center of the circle.

Figure 26f
Ellipses are used to construct the top and bottom of this cylindrical object. As always the major axis of the ellipse is slightly in front of the object's perspective center.

Observe that the vertical sides of the cylinder are tangent to the top, but not at the true diameter of the circle. The sides are tangent to the major axis of the ellipse. As shown in Figure 26e, this will always occur because the major axis is the widest part of the ellipse and therefore is the limit of how far the viewer can see around the cylinder.

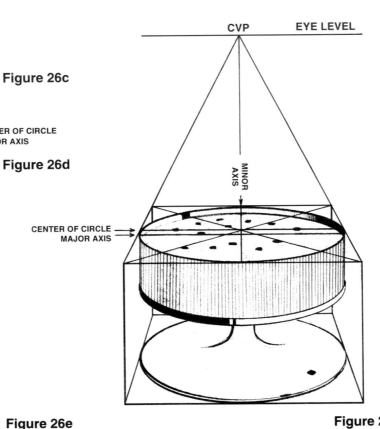

CVP EYE LEVEL

MINOR AXIS

CENTER OF CIRCLE
MAJOR AXIS

Figure 26f

Exercise:

When drawing circles freehand, it is important to practice drawing circles at various positions relative to the picture plane. Select some simple cylindrical object such as a drinking glass, cup or cooking pan. Critically observe the object from several angles focusing on the structure of the subject. Record what you see through a series of freehand sketches.

Procedure:

1. Use a piece of 11"X14" white drawing paper.
2. Using your subject as a model, draw the object from various angles.
3. Draw freehand without the use of a straight edge.
4. Keep any construction lines light and to a minimum.

Figure 27a

This drawing shows the relationship between major and minor axes in the construction of a wheel. As always the major and minor axes are at right angles to each other. Once again, note that the major axis of the geometric ellipse is in front of the perspective center of the circle. This is the widest part of the perceived circle in perspective. Observe that the axle of the wheel is in line with the minor axis of the geometric ellipse. This alignment holds true only for circles that are near the center of the cone of vision.

Figure 27b

This one point perspective illustration combines circular and straight line forms. The following observations serve as a summary of one point perspective principles.

The lines of the fork lift which are parallel to the picture plane remain parallel to each other in the drawing. All of the receding lines perpendicular to the picture plane converge at the central vanishing point on the eye level. Note the rear wheel of the fork lift is an exception in that it is at an angle to the picture plane, and as a result is drawn in two point perspective.

The upright supports of the driver's cage do not converge at a vanishing point. The sides of the cage are not parallel to each other; instead they are angled toward one another. If the sides were extended upward they would eventually come to a point, forming a pyramid.

The circular forms of the wheels are represented by geometric ellipses. The front wheel is in one point perspective while the rear is in two point perspective. In each case the minor axis of the geometric ellipse aligns with the axle for the wheel.

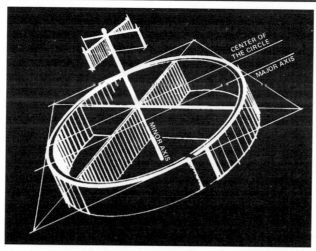

Figure 27a

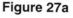

EL CVP

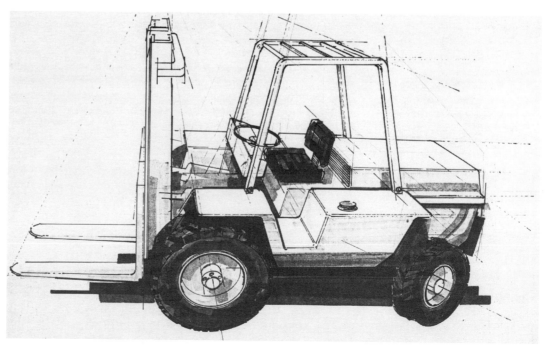

Figure 27b

Exercise:
Figure 28a illustrates the unique relationship between one and two point perspective. Analyze the structure of this scene by completing an overlay which locates the eye level and primary vanishing points. Close observation will reveal what appears to be the central vanishing point, near the left edge of the composition.

Procedure:
1. Tape a piece of tracing paper in place over Figure 28a.
2. Using a straightedge trace a few of the receding edges of the streets and buildings in the left portion of the drawing.
3. These lines will intersect very near the small "x" indicated on the horizon near the left edge of the page. Label this point VPL for vanishing point left.
4. Using a long straight edge, trace the horizontal edges of a few buildings running from left to right across the page.
5. These lines intersect several feet off the right edge of the page. This point is called VPR for vanishing point right.
6. Connect VPL and VPR to locate the eye level which lines up with the horizon in the drawing.

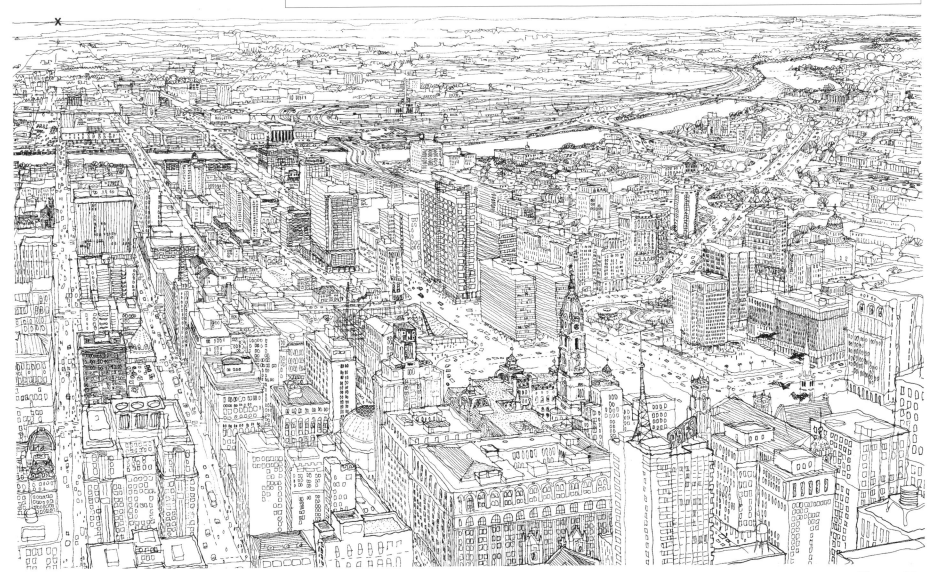

Figure 28a

The difference between one point perspective and two point perspective is rather simple. To be in one point perspective a rectangular object must have one side parallel to the picture plane. Consequently, the receding sides of the rectangle are perpendicular to the picture plane and converge at the central vanishing point.

Many of the one point perspective principles also apply to two point perspective. The picture plane remains vertical in both one point and two point perspective. As a result all vertical lines in the drawing remain truly vertical. The vertical lines are parallel to each other and to the picture plane.

In two point perspective the sides of the object are at an angle to the picture plane. This results in the receding edges of each side converging at one of two separate vanishing points. These are referred to as vanishing point left (VPL) or vanishing point right (VPR).

Figures 29a and 29b

These drawings demonstrate how a one point perspective grid can be used to locate a cube which is actually in two point perspective. This principle requires the construction of a plan view in which the cube is positioned on a one foot grid as shown in Figure 29a.

The grid is then drawn in one point perspective using principles previously discussed. The location of the corners of the cube can then be plotted on the grid as shown in Figure 29b.

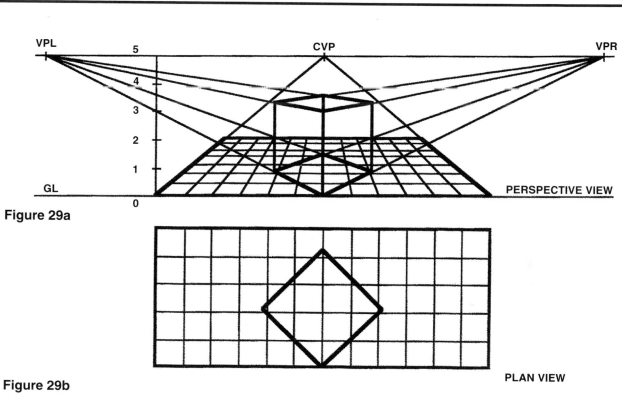

Figure 29a

Figure 29b

Exercise:

Construct a 3' cube that is on the ground plane and touching the picture plane.
Use Figures 29a and 29b as a guide for this drawing.
Use 11"X14" drawing paper or larger.
Use a scale of 1/2"=1'
Establish a normal eye level of 5'.
Station point is 10' from the picture plane.
Position the cube at a 45° angle to the picture plane.

Note:

When a cube is constructed at a 45° angle to the picture plane, VPL and VPR are located on the special vanishing points for the diagonals of the one point grid.

Procedure:

1. Draw the cube in plan view on a 1' grid in scale.
2. To begin the construction of a one point grid draw the ground line and establish a line for measuring height.
3. Use the measuring line to measure up 5' and draw a normal eye level across the page.
4. Locate the central vanishing point (CVP) near the center of the drawing. Position vanishing point left (VPL) and vanishing point right (VPR) 10' to each side of the CVP.
5. The one point grid is then drawn in perspective using the procedures previously covered. Note that VPL and VPR are at the same location as the special vanishing points for one point perspective grid construction.
6. Plot the bottom corners of the cube using the plan view for reference.
7. Draw the receding lines for the bottom edges of the cube from the plotted corners back to VPL and VPR.
8. On the picture plane draw the front vertical of the cube 3' tall to establish the top front corner of the cube.
9. From the top front corner of the cube, draw receding lines back to VPL and VPR to establish the top front edges of the cube.
10. To complete the cube, draw the remaining verticals and converging lines for the back top edges.

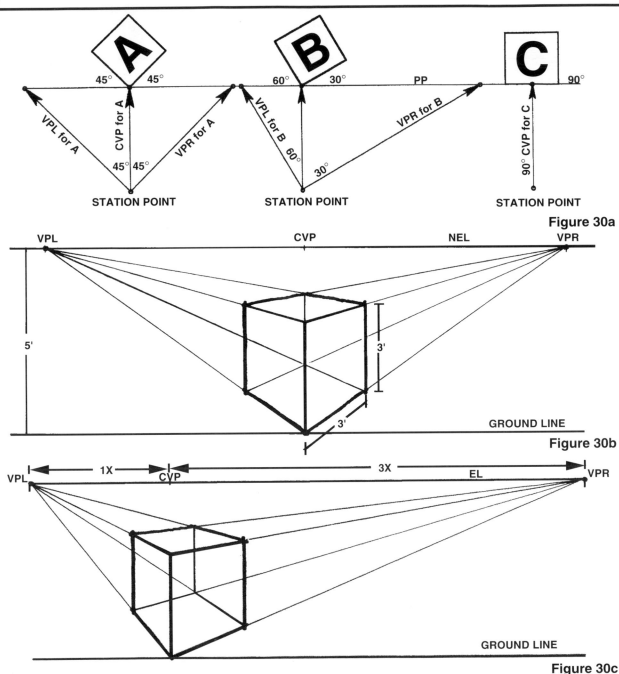

Figure 30a

Figure 30b

Figure 30c

The cube is the basis for innumerable other forms.
It is necessary then to master the ability of drawing the cube freehand. Freehand drawing does not imply guessing. The objects are estimated using objective calculations based on the principles of linear perspective, structural knowledge and the artist's intuitive abilities.

Figure 30a

When mastering cube construction it is critical to control the angle of the cube in relationship to the picture plane. As the angle of the cube changes, placement of VPL and VPR must change as well. This is illustrated showing top views of the cube positioned at three different angles to the picture plane. To determine placement of VPL and VPR, lines have been drawn from the station point parallel to the sides of the cube. The intersection of each line and the picture plane determines the placement of the vanishing point.

The left drawing shows the cube from page 29 positioned at a 45° angle to the picture plane. The middle drawing shows the same cube repositioned with the sides 30° and 60° to the picture plane. Observe that as the angle of the cube moves away from 45°, VPL and VPR shift the same direction along the eye level and become farther apart. This will continue until the cube is once again parallel to the picture plane as shown in the right drawing. Here the cube is in one point perspective.

Figures 30b and 30c

When precise drawings are required it is possible to draw the top views and measure distances to vanishing points. However, this is time-consuming and not necessary for freehand drawing. It is more practical to estimate the relative placements of VPL and VPR using a ratio of distance from the CVP.

Figure 30b:

The cube drawn at 45° is constructed with VPL and VPR positioned equal distance from the CVP or a ratio of 1:1.

Figure 30c:

The cube drawn at 30°/60° to the picture plane is constructed with the distance to VPL three times that of VPR, a ratio of approximately 1:3. Also note that the distance between VPL and VPR is increased slightly to accommodate the shift in vanishing points.

FREEHAND DRAWING

When a precise technical drawing is required, one of the most common methods is to use a perspective grid to assist in the drawing as shown on page 29. Also available are commercially produced perspective grids that are occasionally used to execute exacting renderings. Another method of constructing technically accurate drawings is to use a method referred to as the plan projection method.

The plan projection method requires the preparation of detailed orthographic views. These include a plan view much like those shown in Figure 30a and side views or elevations. The plan view is used to determine placement of vanishing points and to carry out extensive mechanical projections to produce the drawing. Seldom does the designer have the time required to employ the laborious mechanical constructions needed for plan projection, nor be able to work within the limitations imposed by commercial perspective grids.

It is the intention of this book to focus on simpler, faster methods of drawing that serve the needs of developing and practicing artists and designers. For this reason the detailed procedures of plan projection are not covered; rather the direct perspective method is explained in detail. As stated earlier, it is important to become sensitive to spatial relationships and structural concerns. The artist must be able to judge depth in relation to the other elements in the composition, as a result, at this time the concept of estimating is introduced. This will combine the mechanics of linear perspective and the visual acuity of the artist to judge spatial relationships and proportion.

Cubes are used as subjects in the first few examples for two important reasons. First, the cube will later be used as a unit of measure. It can be divided or multiplied into an infinite number of other forms. Second, the cube by definition has six equal square sides and is an easy subject to evaluate. The more complex the objects are, the more difficult it is to determine their degree of accuracy, while almost everyone is qualified to judge a drawing of a cube.

Figure 31a

The seven blocks in this drawing are intended to be cubes. Most of them have errors in construction or in visual estimation. To learn how to avoid these common errors follow the instructions for the exercise.

Exercise:

Analyze these seven blocks and correct any errors on a tracing paper overlay. Revise the blocks so they appear to be cubes.

Procedure:
1. Tape a piece of tracing paper in place over Figure 31a.
2. Referencing block G, locate VPL and VPR on the EL.
3. Without changing the height of each block, redraw each cube freehand, correcting for errors in construction or visual estimation.
4. Add two additional cubes to the drawing, one above eye level and one below.

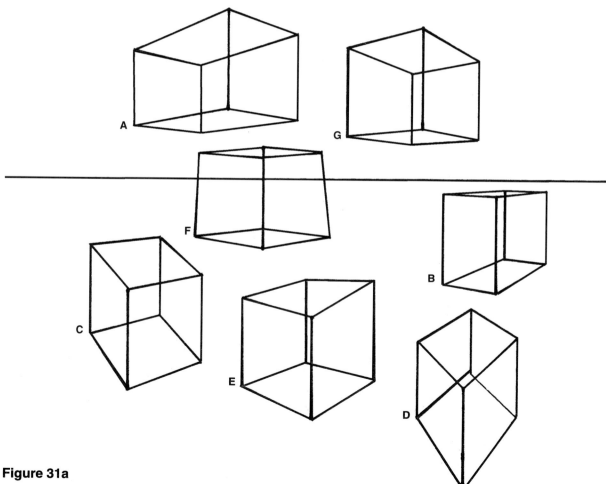

Figure 31a

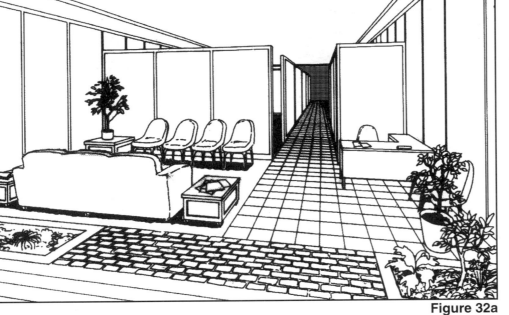

Figure 32a

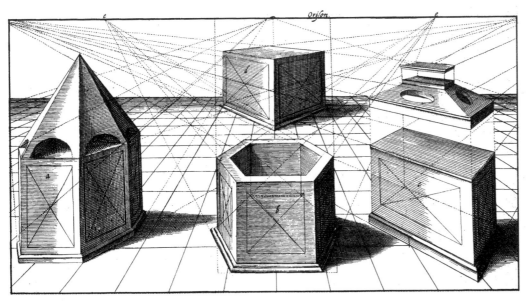

Figure 32b

Exercise:

Construct four eight inch cubes full size on separate pieces of paper. Draw each cube freehand without the use of any mechanical aids such as rulers or straight edges. Once completed, check the accuracy of each cube using drawing equipment and construction methods.

Procedure:

1. On separate sheets of 11"X14" drawing paper construct four eight inch cubes, ten inches below the eye level. Position each cube at different angles to the picture plane. Estimate the size, placement and location of vanishing points for each cube.
2. Visually analyze your drawings as you progress, looking for the common errors shown on page 31.
3. After completing the drawings, tape each to a large smooth drawing surface. (A floor or wall will do.)
4. Verify each drawing's accuracy by projecting receding lines back to their respective vanishing points. These will be off the page and will require using a long straight stick or length of string. Make corrections as you progress.
5. Determine the eye level by connecting the vanishing points. Confirm that all receding lines converge at vanishing points and that the eye level is horizontal.

Figure 32a

This interior is an exaggerated use of two point perspective. The central ray of vision is near the left third of the drawing. Vanishing point right is at the end of the hall. Much of the room is beyond the right side of the cone of vision, resulting in extreme distortion. The artist has purposely drawn beyond the cone of vision to achieve a dramatic effect. A thorough knowledge of perspective principles is imperative to control such extremes. There are many objects in this interior but only two vanishing points are used because the objects are parallel to each other and at the same angle to the picture plane.

Figures 32b

This 16th century illustration shows that there may be any number of vanishing points in a two point perspective drawing. A one point perspective grid was used to position the objects at various angles to the picture plane. The objects in the lower left and right corners of the drawing are beyond the cone of vision and are distorted. Each set of parallel receding lines converge at different vanishing points. This drawing is still considered two point perspective because the picture plane is parallel to the vertical lines of the objects.

DIVISION OF THE CUBE

Diagonal measurement is the basis for determining most perspective depth measurements. The concept is based on the simple fact that the diagonals of any square or rectangle will always intersect at the center of the shape. This principle was introduced earlier in one point perspective (see page 20). In two point perspective diagonal measurement is used to divide and multiply the basic cube into an infinite variety of other more complex forms.

Figure 33a

These drawings demonstrate how a square surface can be divided using the diagonal method. The simplest method is to use diagonals to find the center of the surface. The center can then be used to establish quadrants, thus dividing the square into four equal divisions.

The same process can then be used an infinite number of times to continue subdividing the square into progressively smaller squares.

Figure 33b

Beyond the simple division of a square into quadrants, diagonals can be used to locate any point within a square surface. In this example several variations of diagonal measurement are used to locate points on a surface. These points can then be used to define details or alter the shape of the surface.

The principle is that any measurement can be transferred from one edge to a perpendicular edge through the use of a 45° diagonal. This is accomplished in the first drawing, measuring vertically three inches, then projecting to the vanishing point to establish a receding line. Where this line intersects the diagonal establishes the depth measurement. The depth measurement can then be projected vertically to transfer the measurement to the foreshortened base of the square. Note the additional examples showing the application of this principle.

Figure 33c

This developmental sketch of an electronic component system was constructed using a cube at 30°/60° to the picture plane. The diagonals are used to divide the original cube into the smaller rectangular volume that defines the general form. Additional diagonals were used to subdivide this rectangle as a means of locating and drawing the controls and other details of the product illustration.

Figure 33a

Figure 33b

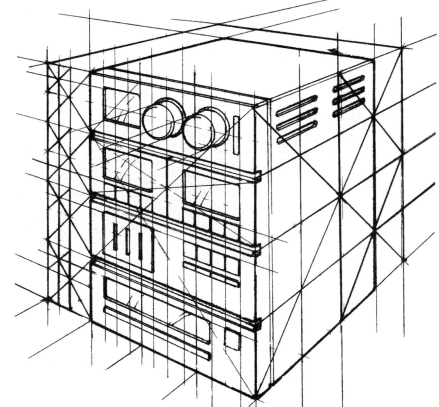

Figure 33c

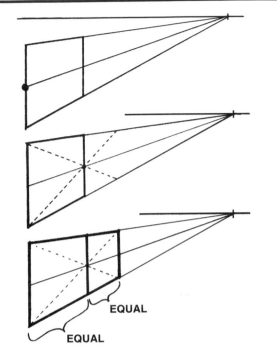

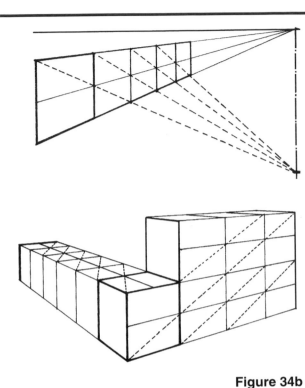

EQUAL

EQUAL

Figure 34a

Figure 34b

MULTIPLICATION OF THE CUBE

There are many occasions when the depth in a drawing far exceeds the represented height or width. Consequently, constructing the subject from divisions of a single large cube would be impractical. Such occasions call for the multiplication of a smaller cube to generate the form. Multiplication of squares and other rectangular shapes is used to add equal measurements along receding lines. These measurements are multiples of a predefined square or rectangle. This method is referred to as the Diagonal Bisector Method of multiplication.

Figure 34a

This drawing introduces the concept of surface multiplication. The procedure is explained in the following steps.

First a square is constructed of a convenient size. Next the top and bottom receding horizontals of the original square are extended back to their vanishing point. The midpoint of the front edge is located and a receding line is projected to the vanishing point. This is to determine the midpoint of the back vertical. A diagonal is projected from either front corner of the square through the midpoint of the back vertical, establishing the depth measurement for the next multiple of the square. Note that only one diagonal is required to project the depth measurement.

Figure 34b

In this example a variation of the previous procedure is used to establish a row of perspective cubes. Notice that in the first drawing a special vanishing point is located directly below VPR and serves as the vanishing point for the projected diagonals. A variation of this principle can be used to measure in any direction, horizontal or vertical. This procedure is then repeated to draw additional cubes in perspective. All of the diagonals are parallel to each other and thus recede to a common special vanishing point.

Figure 34c

These multiplication methods can be used to draw any equally spaced, foreshortened squares or rectangles. In this figure, the windows are equally spaced along the side of the car by using the multiplication method. Note the use of diagonals to divide the front of the car into three equal vertical panels. Even the pavement pattern on the loading platform was constructed using diagonals. Multiplication and division through the use of projected diagonals is one of the simplest and most accurate methods for measuring foreshortened measurements.

Figure 34c

SPECIAL VANISHING POINT METHOD

An important factor in the use of the special vanishing point method is that it can be implemented only after a "known perspective depth" has first been established in the drawing. In other words, the special vanishing point method cannot be used in place of estimating a cube. Once the original cube is drawn the special vanishing point method can be used to divide or multiply the cube into any number of shapes. The unique function of this method is that it can be used to determine unequal as well as equal measurements.

Figure 35a

The special vanishing point method is used here to divide one side of the cube into five equal divisions.

Exercise:

Use Figure 35a as a guide.
Use 11"X14" drawing paper or larger.
Construct a cube of chosen size in two point perspective.
Use the special vanishing point method to divide one side of the cube into five equal divisions.

Procedure:
1. Construct a cube as previously described.
2. Draw the measuring line (ML). It must be horizontal and begin at the near end of the receding line to be divided, in this case the front bottom corner of the cube.
3. Divide the measuring line into five equal parts. Any scale may be used. However if the measurement becomes too large, the special vanishing point may be off the page.
4. Project a line from the fifth measurement through the far corner of the side to the eye level. This intersection locates the special vanishing point (SVP)
5. Draw construction lines from the measurements on the measuring line toward the special vanishing point, stopping at the edge of the cube. These intersections are the foreshortened measurements.
6. Complete the divisions by drawing vertical lines up the right side of the cube from the established intersections.

Figure 35b

Here the special vanishing point method is used to divide the same cube into unequal divisions. The same procedure is used, however the difference is the unequal divisions marked on the measuring line. Any variation of measurements can be transferred back in space using this procedure.

Figure 35c

Three additional blocks are added to the original block by use of the special vanishing point method of multiplication.

Exercise:

Use Figure 35c as a guide.
Use 11"X14" drawing paper or larger.
Construct a cube of chosen size in two point perspective.
Use the special vanishing point method to multiply the block three times back in space.

Procedure:
1. Construct the original block.
2. Draw the measuring line (ML) this time for the left side.
3. Using a scale that is convenient, place four equal measurements on the measuring line.
4. A construction line is drawn from the first measurement through the left corner of the block until it reaches the eye level. This location is the special vanishing point (SVP).
5. The bottom edge of the cube is extended to VPL and receding diagonals are drawn from the remaining measurements to the SVP. The intersection of each line and the bottom receding line indicates the location of each successive block.

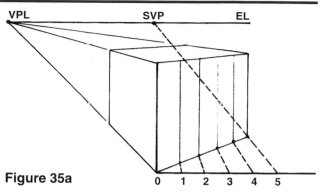

Figure 35a

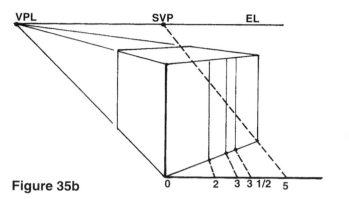

Figure 35b

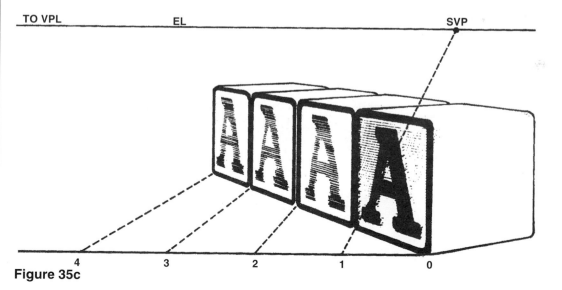

Figure 35c

SPECIAL VANISHING POINT METHOD

Figure 36a

This series of drawings explains some of the theory behind the special vanishing point method. This figure shows two examples of the same subject, including a top view and a perspective view. The top view shows the principles of geometric construction that are being used. The perspective drawing shows the geometry as it appears foreshortened. It is important that the initial length of the rectangular bar is estimated before any measurements are made.

The measuring line is always parallel to the picture plane, permitting direct scale measurements along it. As shown in the top view, the construction line connecting the special vanishing point and the points along the measuring line are actually parallel with one another. The drawing also illustrates why the spaces along the measuring line can be in any scale. Here two different scales have been used for demonstration purposes. Although the change in scale causes a shift in the location of the special vanishing point, the resulting perspective spacing is always the same.

To determine what scale to use on the measuring line, first consider the overall length of the measuring line required. Then plan the number of increments and their relative positions. Avoid having the diagonal construction lines and the receding lines close to parallel. The closer the intersections are to perpendicular, the more accurate the resulting foreshortened measurements. Finally, attempt to keep the special vanishing point on the page whenever possible.

Figure 36b

In this example a variation of the special vanishing point method is used. The subject is the same; however a vertical measuring line has been used to transfer measurements. As before, the measuring line is parallel to the picture plane so the three increments can be scale measurements. The special vanishing point is directly below VPR, on a vertical construction line. It is located at the intersection of the construction line from the third increment and the vertical construction line. The resulting measurements are the same as those in Figure 36a. This variation is useful when the receding line to be measured is close to the eye level.

Figure 36c

Here the special vanishing point method is used to locate an arrow shape on a perspective surface. A plan view of the subject has been positioned against the measuring line to facilitate rapid transfer of measurements. The perspective rectangle was drawn by first estimating a square for the front half. The special vanishing point was used to locate the back half of the rectangle. Dimensions of the arrow are transferred to the measuring line, then to the edges of the rectangle using the special vanishing points. Note that each side has its own special vanishing point. From the transferred measurements, converging lines are constructed to VPL and VPR. The intersections of these lines mark the key points of the arrow.

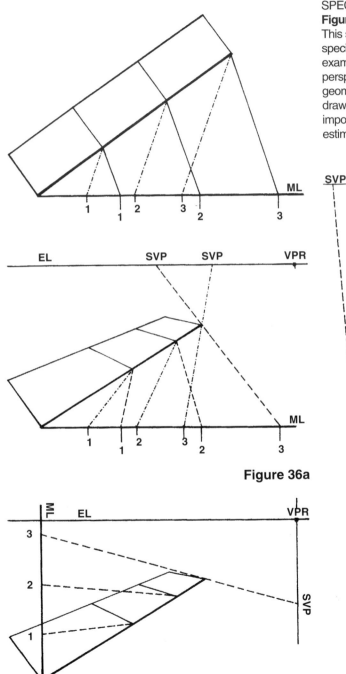

Figure 36a

Figure 36b

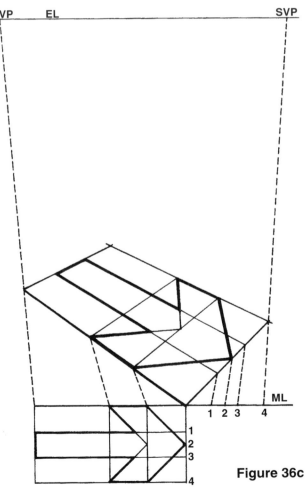

Figure 36c

Auxiliary vanishing points have been defined as vanishing points used for receding inclined planes. An auxiliary vanishing point for an inclined plane is always located directly above or below the vanishing point required if the same plane were horizontal. A vertical construction line is drawn to facilitate alignment of the auxiliary vanishing point. Auxiliary vanishing points are above eye level for planes slanting upward and below eye level for planes slanting down.

A general rule is that the angle of a line to the picture plane determines the placement of VPL and VPR relative to the CVP. Similarly, The angle of an inclined surface determines how far auxiliary vanishing points are from the eye level.

Exercise:

Find a photographic example of an inclined plane. Draw over the photograph to determine the locations of all elements of perspective including eye level, vanishing points and auxiliary vanishing points.

> **Procedure:**
> 1. Mount the photograph centered on a 11"X14" or larger piece of drawing paper.
> 2. Place a piece of tracing paper over the photograph, taping it securely in place.
> 3. Tracing the photograph, locate and label the perspective structure of the subject, including auxiliary vanishing points.

Figure 37a

The roof of this building contains two inclined planes. The lines along the edge of the roof are in the same plane as the side of the building and therefore they are the same angle to the picture plane. This accounts for the auxiliary vanishing points being located above and below vanishing point left which is for the horizontal lines of the building. The two auxiliary vanishing points are equidistant from the eye level because both roof surfaces are at the same angle to the eye level.

Figure 37b

This illustration is an application of auxiliary vanishing points. The auxiliary vanishing point for one side of the "roof" is near the top of the page. Note that it is directly above vanishing point right. Not shown in the illustration is the second auxiliary vanishing point for the back side of the roof. It is located below the eye level and off the page.

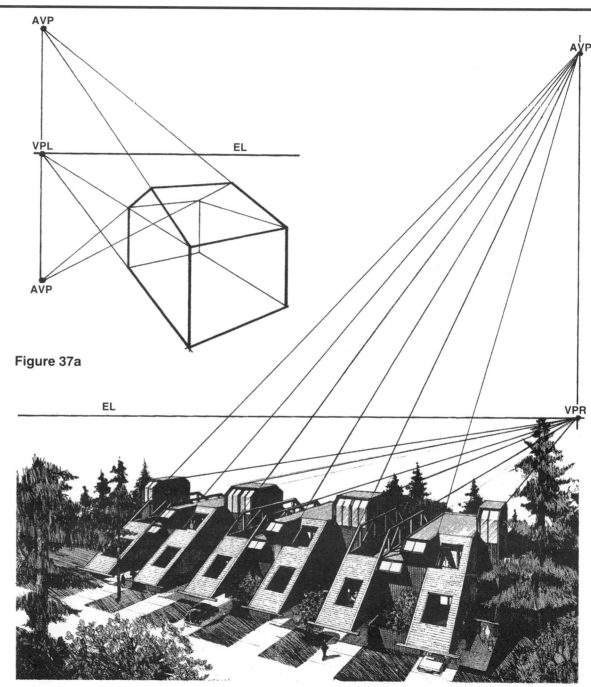

Figure 37a

Figure 37b

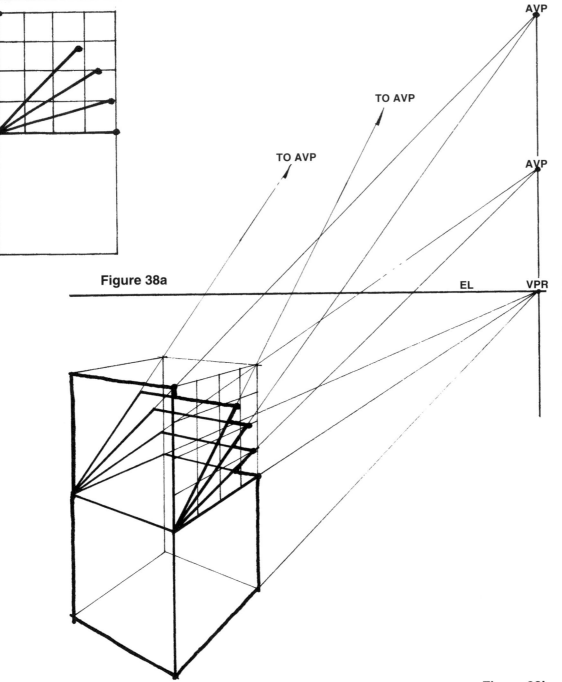

Figure 38a

Figure 38b

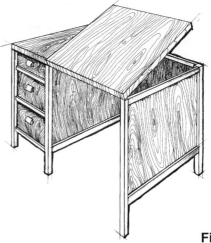

Figure 38c

Figures 38a and 38b

Figure 38a is the side view of a box. It shows the lid in several positions. The purpose of this drawing is to establish the corner location of each lid in relation to the square which has been constructed on the top of the box.

Figure 38b is a perspective view of the same box with the lid constructed at each location as established in the side view. The procedure for this construction is outlined below.

1. The box is drawn using a cube as the unit of measure.
2. Another cube is constructed on top of the box and a grid is drawn on the right side.
3. The corner of the lid is located on the grid.
4. The auxiliary vanishing points (AVP) for the lids are found by extending the near side of each lid until it intersects the vertical line drawn through VPR.
5. The far side of each lid is found by drawing lines from the left corner of the box to the appropriate AVP.

Note:
 A second grid could have been constructed to locate the far edge of the lid. This is sometimes used when the AVP would fall beyond the page.

Figure 38c

In this example the sides of the desk top converge toward an auxiliary vanishing point above VPR. Although the construction lines are not shown for this drawing, the original drawing began with a cube. The corners of the top were located using the same method described above.

PRINCIPLES OF APPARENT SCALE

Apparent scale refers to the size a drawn object appears to be. There are several elements that contribute to the perceived size of a drawn object. However the most basic is the size of the cone of vision.

The cone of vision is regulated by the placement of VPL and VPR relative to the CVP. As the vanishing points are moved closer together the cone of vision becomes smaller. Objects drawn physically the same size will fill more of a smaller cone of vision. This creates the illusion that the object is either being held very close to the station point, or that the object is quite large. The latter is the more common assumption.

The placement of an object relative to the eye level also enhances the illusion of scale. It is our natural tendency to perceive the eye level of a drawing as what we see most often, that being a normal eye level of approximately five feet. By taking advantage of this perception, objects placed below eye level appear smaller and objects near or at eye level appear larger.

The addition of detail to the object and the environment will complete the illusion of scale. When adding detail it is best to play upon the experiences of the viewer. Place objects in the environment that are easily recognizable and provide clues to their size and proportion. The inclusion of the human figure is the most common method of providing a reference for scale.

Figure 39a,
In this drawing VPL and VPR are placed far apart, resulting in a large cone of vision. The cube has been positioned well below the eye level thus enhancing the perception that the object is small. The details are easily recognizable and leave no doubt as to the size of the object.

Figure 39b
Here, the same size cube is placed within a smaller cone of vision. The eye level is now within the frame of reference, just above the cube, implying a normal eye level. The addition of crate detailing and the figure in the environment, complete the sense of scale.

Figure 39c
This final example appears to be the largest, filling most of the cone of vision. The perceived normal eye level passes very near the bottom of the object. The addition of very small figures makes it clear that the cube is now a building.

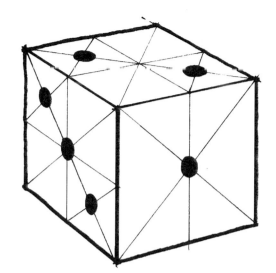

Figure 39a

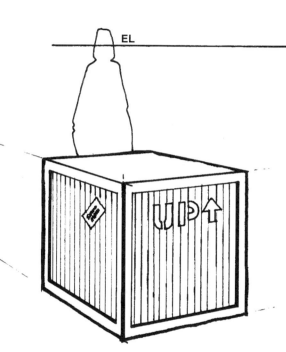

Figure 39b

Figure 39c

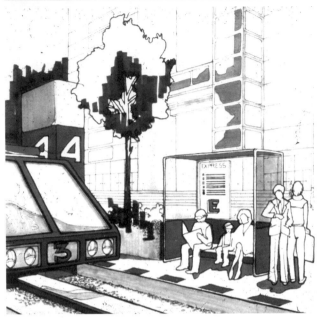

THE FIGURE AND APPARENT SCALE

As discussed on page 39, the inclusion of environmental details is critical to the realistic portrayal of scale. The addition of a human figure to the environment provides the viewer with clues as to the size of the subject. This use of the human figure is one of the most effective methods of indicating scale in a composition.

Simplified figure indication in perspective drawings is difficult for most beginners. Typically the figure is drawn overly detailed without addressing critical proportional and spatial concerns. For the purpose of showing apparent scale the simple suggestion of the human form is sufficient. However the size and overall proportion of the figure is critical.

Figure 40a

This example of student work relies on simplified figure indication to develop a sense of scale and realism. The figures indicated as simple outlines provide a scale reference for the composition.

Figure 40a

Exercise:

Compose a series of apparent scale examples, selecting as your subject a small, easily recognizable object. Make three drawings of the object, changing its apparent scale in each. Use variations in the cone of vision, relationship to the eye level and environmental details to successfully complete the illusion. The drawings of the object should be the same size but the object should appear to become progressively larger.

Use the Figures on page 39 as reference.
Use three 11"X14" sheets of drawing paper.
Adjust the scale relative to each drawing
Establish a normal eye level of five feet throughout.
Station point is relative to the cone of vision

Procedure:

1. Establish a scale that is appropriate for each drawing.
2. In each case construct a normal eye level and place the ground line in scale five feet below the eye level.
3. The station point should start out quite distant from the picture plane for the small object. As the size of the object increases, the station point should get closer to the picture plane, reducing the cone of vision.
4. Construct the structure of your subject using the vanishing points as defined by the cone of vision. Keep the angle to the picture plane consistent throughout.
5. Finalize each drawing by adding detail to the subject that reflects the change in size. Additional detail should be added to the environment that provides a reference for size.

Note:
 Care must be taken to not distort the subject as the cone of vision is reduced. The intent is to capture a realistic change in scale.

Figure 40b

In this concept proposal for a retail space the designer uses a dramatic point of view to reveal the interior details of the space. Despite an elevated station point, the perception of scale and spacial order rely upon the use of figure representation. Without the use of simplified figure representation is would be difficult to convey a sense of reality in this composition. The finished rendering of this retail space is presented in figure 83b of the portfolio examples.

Figure 40b

Perhaps the most common method of drawing complex designs and two dimensional curves in perspective is by the use of a perspective grid. The concept of a perspective grid was introduced in the section on one point perspective. The use of a grid is both quick and accurate. The accuracy of the grid increases as the grid pattern becomes smaller. Usually the more intricate the design the finer the grid pattern is drawn.

In this method, the design must first be laid out on a flat, two dimensional grid. The grid normally consists of squares although it can be made of rectangular shapes as well. The same grid is then drawn in perspective. The coordinates of the design are transposed from the flat grid to the perspective grid. Finally, lines are drawn between the points to complete the perspective drawing of the design. Any receding lines that result should be checked against the vanishing points to confirm the accuracy of the construction.

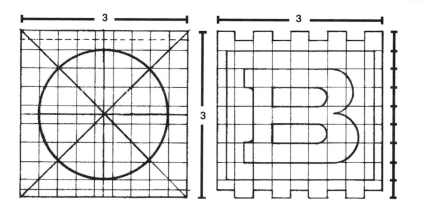

Figure 41a

Figure 41a

This drawing of a child's block demonstrates an application of a two point perspective grid. These two drawings are side views of the designs that are transposed onto the perspective grid of the block.

Figure 41b

This is a perspective drawing of the completed block with the graphic designs plotted onto the perspective grid.

Exercise:

Draw the child's block in two point perspective using the information provided in Figure 41a.
Use 11"X14" drawing paper or larger.
Scale 1 inch equals 1 inch or full size.
Establish an eye level of choice.
Locate the block below eye level.

Procedure:
1. Draw a three inch cube full size, against the picture plane.
2. Divide the front vertical of the cube into nine equal parts and draw horizontal lines back to the vanishing points.
3. Construct the diagonal of each side of the block to locate the vertical lines of the grid.
4. Transpose the coordinates of the design onto the perspective grids.
5. Connect the plotted points of the designs. Where the design involves a curve, the line between points must be estimated. The grid can be used to construct two point circles such as the one on the left surface of the block.

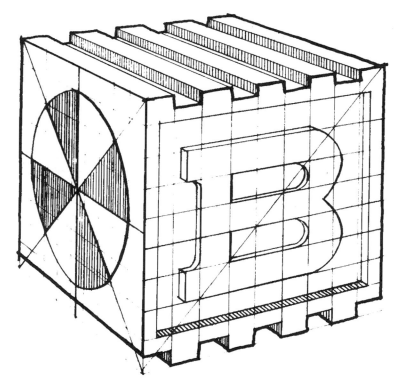

Figure 41b

Figure 42a

One of the most practical applications of two point perspective grids is the construction of perspective typography. The example on this page shows a grid used to transpose the complex curves of a script type face onto a surface that has been foreshortened.

Figure 42a

Here the complex series of curves that make up type are constructed in two point perspective through the use of a two point grid. The first step in this drawing is to lay out the type on the flat grid. A square is estimated in perspective and then the special vanishing point method is used to find the remainder of the perspective grid. The points where the type intersects the original grid are transposed onto the perspective grid. The lines between the points are drawn freehand as is the perspective thickness of the letters.

Exercise:

Select as your subject a commercial package that is essentially a box with text and graphic shapes on its surface.
Construct the box and add detailed text and graphics using a two point perspective grid. The smaller the grid squares, the more precise the finished text and graphics will appear.

Procedure:

1. Trace or copy the package graphics onto a sheet of paper containing a two dimensional grid of appropriate size.
2. Construct the rectangular package in a perspective view that shows the surface containing the text and graphics.
3. On the graphic surface construct a two point perspective grid to the same specifications as the two dimensional grid from step one.
4. Transpose the coordinates of the text and graphics onto the perspective grid.
5. Connect the plotted points of the designs. Where the design involves a curve, the line between points must be estimated.
6. The package illustration is finalized by darkening the drawing and adding the desired details.

Circles in one point perspective were discussed earlier on pages 25 and 26. It is useful to review one point perspective circles because many aspects of their construction can be related to circles in two point perspective.

Circles are indispensable in drawing objects in perspective. Virtually any object is a composite of rectangular and circular forms. Circles are drawn freehand by plotting points along their circumference. The curve of the foreshortened circle is drawn by estimating a smooth curve through these points. As shown on page 41, a grid can be used to construct circles in two point perspective. However this method is usually used to construct more complex shapes. Due to the relative simplicity and common use of two point perspective circles, they are usually drawn by locating eight key points. This method is explained through the examples shown on this page.

Figure 43a

This figure re-examines several constant relationships between the circle and the square two dimensionally and in perspective. The following observations can be made concerning this relationship.

1. The intersection of the square's diagonals is the common center of the circle and the square.
2. The circle touches or is tangent to the middle of each side of the square.
3. The circumference of the circle crosses the diagonals of the square slightly more than two thirds the distance from the square's center to any corner.

This relationship provides eight points along the circumference of the circle which are the eight reference points located within a foreshortened square. A smooth curve between these points completes the circle.

The same eight point method is used to construct vertical or horizontal circles. When constructing horizontal circles, the special vanishing point method is used to find the points on the diagonals. The circle will cross the diagonals just beyond these points.

Figure 43b

This student exercise shows this principle applied to a series of cubes. Observe that no matter how foreshortened the circles become, their relationship to the square remains unchanged. This is true even when the object moves above the eye level as shown in the drawing.

Exercise:
Use the cubes constructed for the exercise on page 32. Use the eight point construction method to draw eight inch circles on the three exposed sides of each cube.

Procedure:
1. Accurately reconstruct the previously drawn cubes on a sheet of 11"X14" drawing paper.
2. On each side, construct diagonals from corner to corner, locating the center of the square.
3. Construct the vertical and receding horizontal lines that pass through the center of each square.
4. Carefully establish points along each diagonal that are two thirds the distance from the center to the corners.
5. Finally, draw each circle freehand by generating a smooth curve that passes through the established eight points.

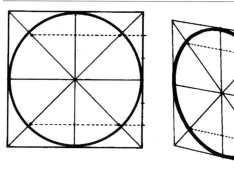

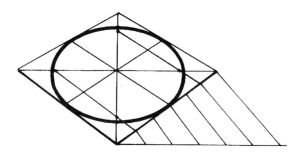

Figure 43a

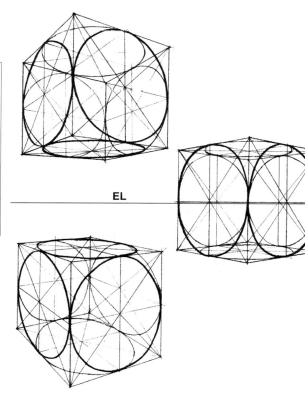

EL

Figure 43b

Figure 44a

This advertisement illustration required many circles within the drawing. A series of ellipse guides were employed to construct concentric circles on the watch's face. It is important to note that ellipse guides seldom fit exactly within the foreshortened squares. Here this slight perspective error was disregarded in favor of producing the very smooth ellipses necessary for the tight technique of the drawing.

Should the object be drawn further from the central ray of vision, the square becomes more distorted. The discrepancy between the true geometric ellipse and the perspective circle becomes greater. The resulting distortion of the square prevents the use of a symmetrical ellipse guide to inscribe the perspective circle. This illustration is centered within the cone of vision which makes possible the use of an ellipse guide.

CIRCULAR GEOMETRIC SOLIDS

As previously stated, virtually any object can be constructed using a composite of rectangular and circular forms. This is achieved through application of the eight point method of circle construction. The use of geometric solids, or primitives that are based on circle construction, is essential when drawing many of the complex forms confronted by the artist.

Pages 44 and 47 show some examples of geometric solids that have been derived using the eight point method of circle construction. In each case a rectangular box is first constructed having the same dimensions as the geometric solid.

Figure 44b

Cylinders are the most common form of geometric solids that employ the eight point method of circle construction. The following method of construction remains consistent whether the cylinder is horizontal or vertical.

To draw a cylinder, first construct the circles which appear as ellipses on the ends of the box. Then complete the outline of the sides by drawing lines tangent to the circles at each end. Note the center line of the cylinder aligns with the minor axis of the geometric ellipse. In addition, the major axis of the geometric ellipse is at 90° to the center line of the cylinder. (Review page 27.)

Figure 44c

Another commonly drawn primitive is the cone. A cone is a geometric solid that has at its base a perfect circle. The sides of the cone converge to a point directly opposite the center of the circular base.

A cone is constructed by first completing a circle for the base. The apex or point of the cone is located where the diagonals cross on the side opposite the base. Draw the sides of the cone by drawing lines from the apex tangent to the circular base.

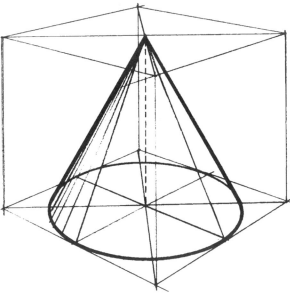

Figure 44c

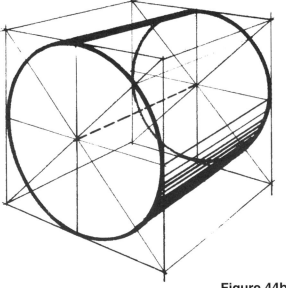

As worn on Earth.

Figure 44a

Figure 44b

Many objects can be constructed using variations of the standard cylinder and cone. In such instances it is often desirable to construct the entire shape then remove or alter portions of the form. This principle is apparent in the examples provided on this page.

Figure 45a

In this example the top of a cylinder has been cut diagonally. When constructing this variation of a cylinder, it is best to construct the base of the cylinder as usual. Then the angled top surface converges toward an auxiliary vanishing point that is above vanishing point left. The inclined ellipse is constructed using the same eight point method that is used to construct vertical or horizontal circles.

Figure 45b

When a cone is lying on its side, a line must be located along the ground on which the side of the cone is resting. The apex of the cone is located on this line. The center line of the cone is aligned with the minor axis of the geometric ellipse forming the circular base. As in the cylinder, the major axis is perpendicular to the center line. It should be noted that technically there are a few exceptions to this statement. However as a rule follow what looks right. The perpendicular relationships as shown are found in most drawings.

Figure 45c

This drawing shows a typical adaptation of these principles in the construction of a small glass tumbler. The geometric solid drawn is referred to as a truncated cone. The diameter of the bottom is less than that of the top rim. Observe how the diagonals of the bottom square are used to symmetrically position the base of the glass.

Figure 45d

This drawing of binoculars demonstrates several variations of ellipse application. It is common when drawing more complex objects such as this, to begin by constructing geometric volumes that make up the basic forms. These volumes are then modified as needed to complete the more complex forms.

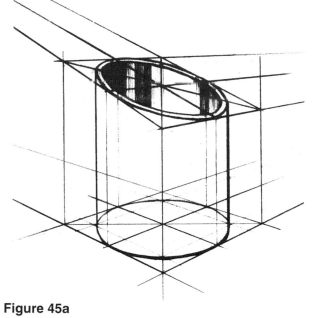

Figure 45a

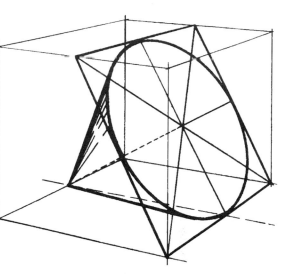

Figure 45b

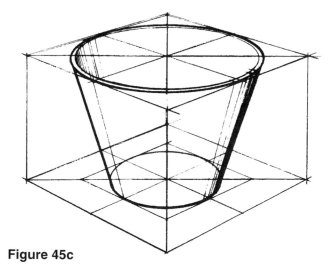

Figure 45c

Figure 45d

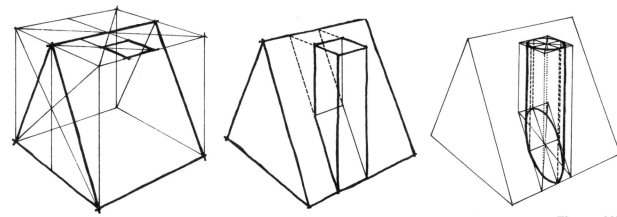

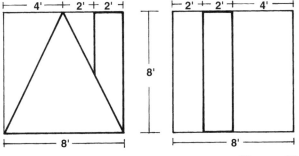

Figure 46b

INTERSECTIONS

Most compound forms are combinations of basic geometric shapes. Consequently, drawing such objects requires the construction of intersecting geometric solids. Understanding the anatomy or structure of an object and visualizing it as transparent is helpful in drawing intersections.

Where two solids intersect, a line is formed which defines the plane of the intersection. This plane is constructed by first locating points of the intersection on the surface of the objects. Often the original construction lines of the object can be used to locate these points. Lines of the intersection on curved surfaces are estimated on the surface of the object, between known points along the intersection.

Figure 46a

Figure 46a
Above is the information needed to draw the roof top and chimney in perspective.

Figure 46b
The basic construction of the roof structure is placed inside a rectangular box. The top of the chimney is placed on the top of the box. Next, lines are projected from the chimney top to the peak and base of the roof. These points are used to locate two parallel lines on the roof surface. The verticals of the chimney intersect the chimney along these lines. The intersections of the projections form the four corners of the intersecting forms. Finally, the square chimney has been converted into a cylindrical vent. The above construction is completed then the eight point construction method is used to draw the cylinder. The eight reference points are projected from the top down to the roof surface. The points are connected with a smooth curve which forms the plane of the intersection.

Figure 46c
This illustration of a roof with a dormer and chimney is an example of the principles previously illustrated.

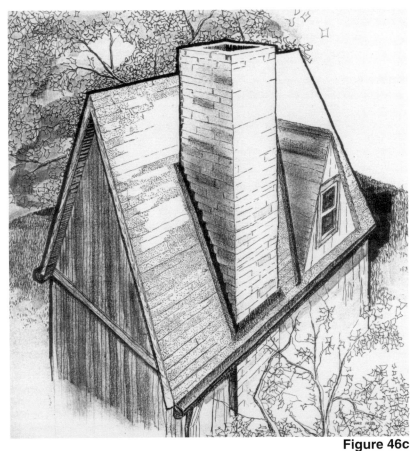

Figure 46c

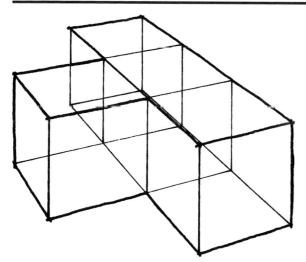

Figure 47a

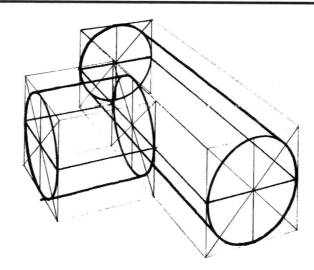

Figure 47b

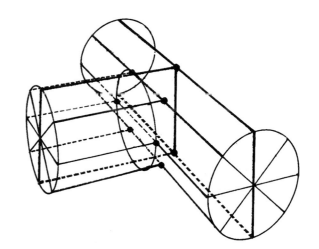

Figure 47c

This page demonstrates the procedure for constructing a pipe fitting that is essentially two cylinders. The intersection between two cylindrical shapes occurs frequently when drawing complex objects.

Figure 47a
The first step is to construct two rectangular boxes having the same dimensions and position as the cylinders.

Figure 47b
Two cylinders are drawn within the boxes using the eight point method previously explained. The points of the cylinders are required in the construction of the intersection.

Figure 47c
Find the point of the intersection along the vertical and horizontal center lines of the cylinders. Next, use the diagonals on the cylinders' ends as a reference to locate four additional points of intersection. (Dashed lines.)

Figure 47d
Connect the eight points of intersection with a smooth curved line which defines the intersection for the two cylinders. If greater accuracy is required, more points of intersection could be found before the intersection is drawn.

Figure 47d

Many of the complex forms that are drawn result in lines that are three dimensional curves. Three dimensional curves are best constructed through the use of sections or cross sections of the object. For example, when an orange is cut in half, a circular cross section is exposed. On the other hand, the cross section of an apple is a non-geometric curve. These examples of cross sections are typical of those used in many drawings.

The sphere is a geometric solid that is a basic example of a three dimensionally curved object which does not have any straight lines on its surface. Intersecting sections are used to assist in its construction. Sections may be taken at several locations to develop the structure of the object drawn. This procedure often used for much more complex shapes.

Figure 48a
First construct a cube in which the sphere will be contained. The sides of the cube are the same length as the diameter of the sphere. Three planes or sections are drawn through the center of the cube at right angles to each other. Cross sections of the sphere will be drawn on these planes.

Figure 48b
Using the eight point method, draw a circular cross section on one of the vertical planes through the center of the cube. This procedure is then repeated for the two remaining planes.

Figure 48c
The sections are then superimposed on top of each other, being careful to keep them aligned. The outline of the sphere is drawn as a smooth curve tangent to all of the sections. When the sphere is near the center of the cone of vision, its outline will always be a perfect circle. This is regardless of the angle of the original cube to the picture plane.

There are several reasons for constructing the sphere using this system. First, the point where the sphere touches the ground plane is established by the intersection of the vertical sections. Second, the elliptical sections can serve as guide lines for drawing details on the surface of the sphere. Finally, the sections provide structure that is required for cutting into the sphere or plotting intersections with other objects.

Figure 48d
The drawing of the orange is developed in the same manner as the sphere. Shading and detail are added to the surface using the sections as a guide.

Figure 48a

Figure 48b

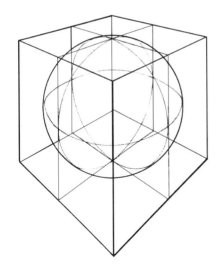

Figure 48c

Figure 48d

The Figures shown on pages 49 and 50 demonstrate the use of sections to draw the complex curves of a snowmobile. It should be noted that the series of drawings is presented for the purpose of explaining the use of sections in the perspective drawing of compound forms. Seldom would an illustrator actually draw each step separately. In addition many of the details that appear in the final illustration were added freehand using the structure as a guide.

Figure 49a,
The three views or orthographic views show the information required for the drawing of the perspective illustration. The drawing includes front, top and side views, as well as a grid structure to measure relative proportions.

Figure 49b
The final illustration shows the artist's structural interpretation of the snowmobile. Many of the details were added freehand using the structure developed in the construction drawing as a guide. The construction lines have been eliminated in this final technical illustration. The construction drawing and procedures are included on page 50.

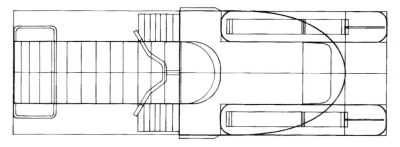

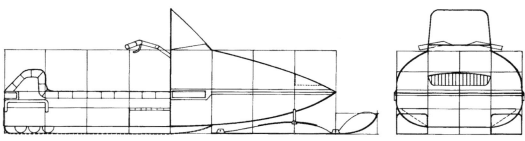

Figure 49a

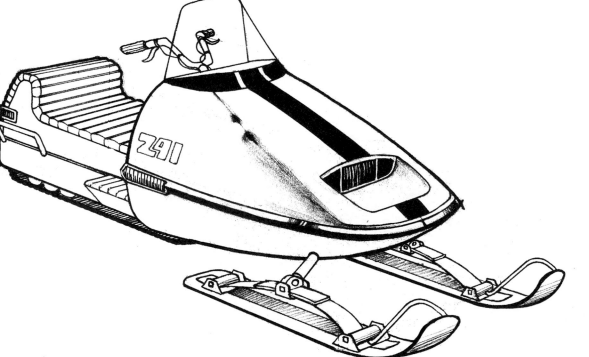

Figure 49b

Figure 50a

Figure 50b

Figure 50c

Figure 50d

Figure 50e

Figure 50f

Figure 50g

Figure 50a: First construct a box having the same dimensions as the body of the snowmobile. This important step determines the proportions of the subject and its angle to the picture plane.

Figure 50b: Draw the planes through the box to locate sections of the object. The shape of the body requires that several sections be located.

Figure 50c: This type of section is common in drawing, as It is along the center line of the object. Draw a perspective grid on the plane and plot points defining a profile for the vehicle.

Figure 50d: Construct another grid on the horizontal plane and locate points around the belt line of the body.

Figure 50e: Locate three lateral sections at critical points on the body. Also develop the basic form of the skis.

Figure 50f: Superimpose all of the sections on one another, excluding the grid constructions. Estimate the outline of the fiberglass shell, using the sections as guidelines. Observe that the outline is tangent to the sections.

Figure 50g: This is the completed construction drawing used for the illustration in Figure 49b. All steps in the construction are presented on one drawing. This method is typically used.

The procedure for drawing these forms varies from that on the previous page. Essentially these are freehand sketches. Drawing these forms requires close structural analysis. The visualization of a form as being transparent is an invaluable aid in comprehending the unique structure of an object. It is a common practice for professional designers and artists to omit some or all of the construction lines in a drawing. The process of construction is performed mentally by visualizing the form. This principle is evident in the portfolio examples beginning on page ?.

Exercise:

Select an object which contains some compound forms. Using the procedure outlined in Figure 51b, complete a series of freehand perspective studies of your subject.

Procedure:
1. Using 11"X14" drawing paper, draw the subject freehand from life and show the hidden lines.
2. Complete three sketches, each from a different angle.
3. Maintain a consistent proportion to the forms throughout.

Figure 51a

This can opener was drawn from life. Relative proportions and other details were drawn by analyzing the forms and then visualizing their structure. Observe how the handles pass through imaginary arcs as they are rotated. These arcs are valuable aids in determining the proper foreshortening.

Figure 51b

This series of freehand sketches are used to investigate a range of conceptual form studies. Maintaining consistency in the character of the form and controlling proportions are key factors when exploring conceptual form development. The artist must practice these principles to be successful in freehand drawing endeavors.

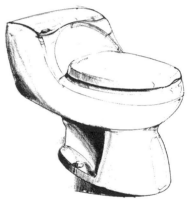

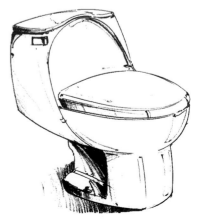

Figure 51a

Figure 51b

The illustrations on this page demonstrate an application of perspective drawing principles relative to product design and development. The use of compound forms is evident in the development of the soft storage features of this baby stroller.

Figure 52a

The initial stages of this product development began with the generation of numerous rough concept sketches. Even in the early stages of development the use of perspective drawing principles are critical to maintaining proportion and a sense of volume.

Figure 52a

Continued development of the initial concept leads to the preparation of a final concept rendering. The rendering evolved using a series of overlays to refine details of the concept and to increase accuracy of the perspective structure. The use of overlays to build up complex forms is a common commercial practice that results in visually accurate renderings in a minimum of time.

Figure 52a

Figure 52b

THE FIGURE IN PERSPECTIVE COMPOSITION

Perspective composition is concerned with establishing proper size and distance relationships in drawings. Linear perspective is used to duplicate the fixed spatial order of reality, creating the illusion of real space. To achieve reality, the relationship of every element in the composition must be established in space.

As the complexity of the subject matter increases so does the difficulty in controlling spatial order within the composition. This becomes particularly apparent in freehand sketching. Without perspective control, objects and figures may float in space or appear out of proportion and scale. These problems tend to become exaggerated in drawing the human figure.

As previously stated in the section on apparent scale, the indication of the human figure is key in establishing scale and spatial order. The vast majority of subjects drawn relate to the human figure in some way. This is obvious when viewing drawings of interior spaces that are void of figures. There is an empty, unrealistic quality to such compositions.

Figure 53a

In any drawing where the intent is to show a realistic portrayal of space, it is essential to establish an eye level. Here a normal eye level is used to place the viewer as an unseen participant in the space. The viewer naturally perceives that he or she is standing while viewing the scene. The first figure is drawn six feet tall. Additional figures are drawn using receding parallel lines to transfer the measurement.

Figure 53b

Here the point of view is that of a seated individual. Note that the eye level passes through the eyes of the seated figure while the eyes of the standing figures are above the eye level.

Exercise:

Working from life, draw an interior or street scene which includes a minimum of five human figures.
You may choose a seated or standing eye level; however, the main figure must be at the same eye level as the viewer.

Procedure:
1. Using 11"X14" drawing paper, construct the structure of the environment and indicate receding guide lines for all figures.
2. Freehand sketch the figures indicating positions in space using horizontal lines as shown in Figures 53a and 53b.

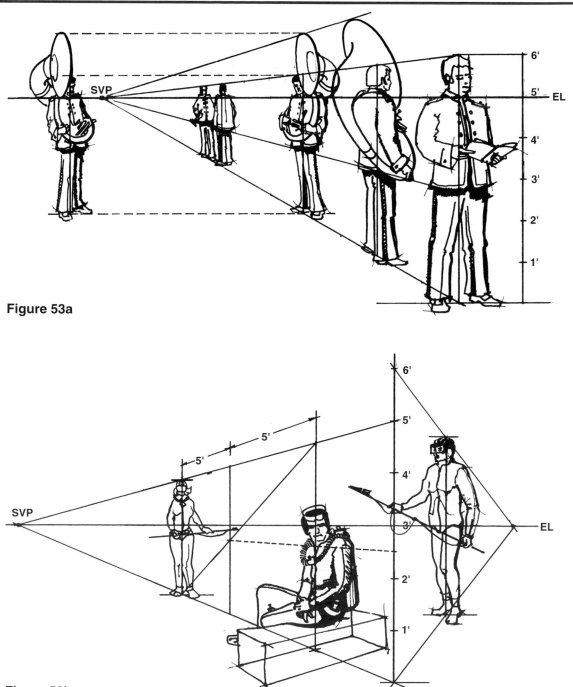

Figure 53a

Figure 53b

THE PERSPECTIVE FIGURE

The human figure is the most demanding of subjects. Attempts have been made to use mechanical perspective methods to draw the figure. These methods have proven cumbersome and generally unsuccessful. Detailed illustration of the human figure requires study of skeletal and muscular structures. These are issues beyond the scope of linear perspective.

Figure analysis reveals underlying geometric forms which can help one see the relevance of perspective to figure drawing. This is apparent in matters of foreshortening and placement of the figure spatially within a perspective composition.

This page shows examples of perspective principles applied to the human figure. These drawings are by artist Burne Hogarth, author of "DYNAMIC FIGURE DRAWING." Here the artist expresses his concern with drawing the figure in perspective.

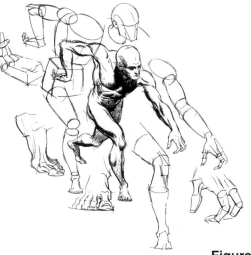

Figure 54a

Figure 54a

"Figure drawing in depth is accomplished with ease and authority when the student becomes aware of the characteristic body forms. He must train his eye to see three kinds of forms in the human figure: ovoid forms (egg, ball, and barrel masses); column forms (cylinder and cone structures); and spatulate forms (box, slab and wedge blocks). These three kinds of forms should be distinguished from one another and studied separately according to their individual differences. Comparisons should be made with respect to relative shape, width, and length; and special emphasis should be placed on variations in bulk, thickness, and volume. This is an approach which seeks to define the body as the harmonious arrangement and interrelationship of its separate and individually defined parts."

Figure 54b

"In the perspective circle, we see that the variable lengths of line are identical and equal in different directions in depth. This means that while these lengths appear to change (foreshortened) because they are put within the control of an ellipse - they are actually unchanged in length. To develop the arm in depth, the initial length is taken from the vertical arm, dropped to the side of the body. The shoulder pivot is moved to the outer side of the arm to relate to the outer elbow point. With this length as an absolute measure of the upper arm, a tight ellipse is put in. A number of straight lines, drawn from the pivot of the ellipse, produce a sequence of foreshortened views of the arm."

Figure 54c

"When it is necessary to work with more than one figure in space, the basic requirement is a good first figure with which to organize the mechanics of the grid system. Then any number of actions may be freely devised throughout the depth plane. Note how the lower leg length carries the projection norm into the spatial track for new figure insertions."

Figure 54b

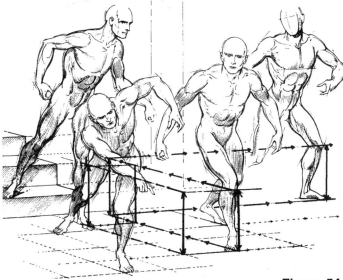

Figure 54c

Reflections can vary greatly in terms of complexity and impact on a composition. Everyone can appreciate the serene symmetry of nature reflected in a pond. In contrast, many have experienced the excitement and confusion prevalent in a carnival house of mirrors. This section of the book covers the basic principles used to draw a wide range of reflective subjects.

The clarity of a reflection is dependent upon several conditions that are interrelated and determine the image that is reflected. The intensity of light and quality of the reflective surface are the key factors in the clarity of the image, while the structure of the reflected image is determined by the angle of the mirror to the picture plane and the distance of the object from the mirror.

A glass mirror is only one common example of a reflective surface. Water, metals, waxed floors and window glass are a few of the countless other reflective materials we encounter daily. For the sake of consistency, this text refers to all reflective surfaces as mirrors. For explanation purposes, the topic of reflections has been divided into the categories of: horizontal, vertical, diagonal, multiple and curved mirrors.

Figure 55a
The theory of reflection is based on the optical rule that the angle of incidence equals the angle of reflection. This figure is a diagram of that principle. The object, represented here by a triangle, is actually reflected where the dashed lines of sight touch the surface of the mirror.

Figure 55b
In practice, the reflection of the object does not really appear to be on the surface of the mirror as shown above. Instead, the reflection of the object appears to be the same distance below the surface of the mirror as the object is above the mirror. This illusion is the basis for constructing reflections in perspective.

Figure 55c
All reflections, regardless of their complexity, are based on this simple diagram. Reflections of objects are drawn by locating the reflection of specific points, one at a time, then connecting these points to complete the reflection of the object.

The distance from a point on the object to the mirror is always measured along a line perpendicular to the mirror. This distance is then duplicated behind the mirror, locating the reflection of the original point.

Figure 55d
Several constants concerning reflections are apparent in this photo. The horizontal reflection is an exact reverse image of the original blocks. The blocks and their reflections are symmetrical because the eye level is close to the surface of the mirror. Finally the reflections of the blocks appear to be the same distance below the mirror as the blocks are above the mirror.

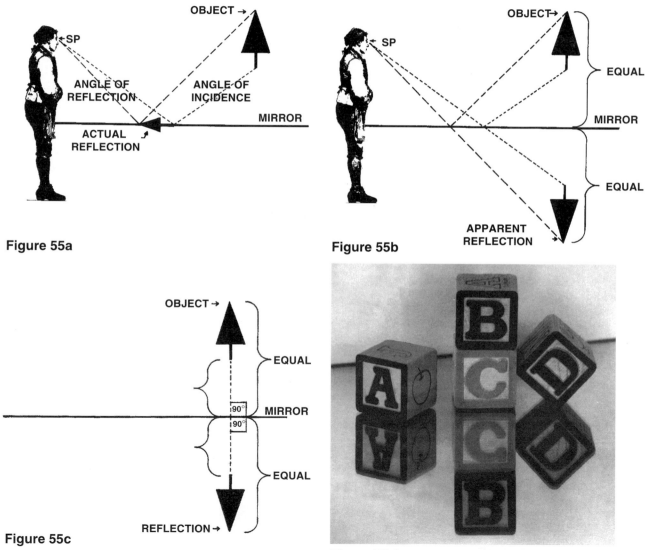

Figure 55a

Figure 55b

Figure 55c

Figure 55d

Figure 56a

Figure 56b

Figure 56c

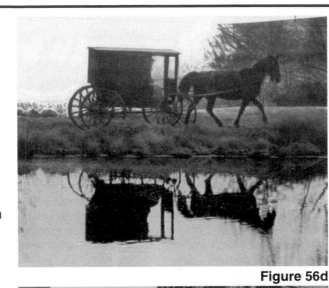

Figure 56d

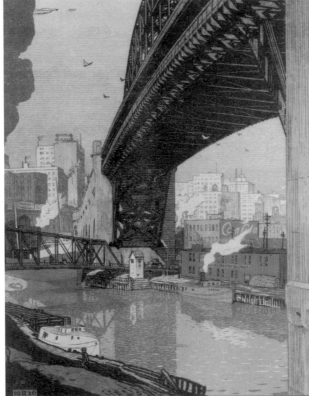

Figure 56e

HORIZONTAL MIRRORS

One of the simplest forms of reflection is a vertical object that is reflected into a horizontal mirror. The key to horizontal mirrors is that vertical measurements are not foreshortened. As a result the object and its reflection measure the same height and distance from the mirror's surface.

Figure 56a

Here a vertical and diagonal post have been reflected into a horizontal mirror. In each instance only the reflection of two points, the top and bottom of the post, are required to complete the reflection. The bottom of each post is touching the mirror; therefore its reflection is directly under itself. The reflection of the top of the post is determined by a measurement taken perpendicular from the top of the post to the mirror's surface. This measurement is then duplicated below the mirror, thus establishing the reflection for the top of the post. Note that in the case of the diagonal post, a construction line on the mirror's surface establishes the measurement. This construction line must be in the same plane as the post.

Figure 56b

Here several objects are shown on a horizontal mirror. From this some general rules which apply to all reflections can be observed. Lines perpendicular to the mirror have reflections that are perpendicular to the mirror. Lines parallel to the mirror have reflections that remain parallel to the mirror and therefore converge toward common vanishing points on the eye level.

Figure 56c

In this example, only the top portion of the object can be seen in the mirror. The triangle is not touching the surface of the mirror as in the previous example. The triangle is sitting on the ground behind the mirror. The reflection is constructed as if the mirror extended back under the object. Only the portion of the reflection which occurs within the frame of the mirror is darkened.

Figures 56d and 56e

Water reflections are constructed the same as horizontal mirrors. The slight variations in the reflective surface distort the reflected image because each ripple in the water acts as a separate convex mirror. This accounts for the apparent breaking up of the reflection in water. The diminution of the ripples in the background creates more distinct reflections. Ripples in the foreground appear farther apart and reflect more distorted images. In addition, water movement tends to obliterate the already vague foreground reflections.

VERTICAL MIRRORS

Though reflections into vertical mirrors require more complex construction, many of the principles discussed for horizontal mirrors still apply. The distance the object is from the mirror is still measured perpendicular to the surface of the mirror and duplicated into the mirror to create the reflection. However the measurement is now foreshortened.

Figures 57a through 57d

The first step in drawing reflections in vertical mirrors is to establish a vanishing point for lines perpendicular to the mirror's surface. Lines perpendicular to a vertical mirror are horizontal and therefore converge on a vanishing point that is on the eye level. In this example vanishing point right is also the vanishing point for lines perpendicular to the mirror. The rectangular base is the common ground used as a reference to establish the spatial relationship of the triangle with the mirror.

In each step, the problem is reduced to finding the reflection of specific points on the object. A rectangle, real or imaginary, is used to perform multiplication procedures for each point.

Observe that lines parallel or perpendicular to the mirror have reflections that are the same. As a result each line and its reflection use the same vanishing point. In other words, the object and its reflection have the same spatial relationship to the mirror.

Figure 57d

In this example a limited portion of the object appears reflected in the actual surface of the mirror. For construction purposes the complete reflection is first constructed. This is done by imagining that the mirror is extended beyond its frame until it intersects the ground. Only the portion of the reflection that falls within the frame of the mirror is darkened.

Figure 57e

Here the special vanishing point method is used to duplicate the measurements behind the mirror's surface. This method can be used as an alternative to the diagonal method shown in Figures 57a through 57d.

Figure 57f

The reflection of the X-ACTO knife and blade dispenser was drawn using the procedures outlined on this page. The reflection of every point appears exactly the same distance behind the mirror as the corresponding point of the object is in front of the mirror. Note the extreme foreshortening of the knife.

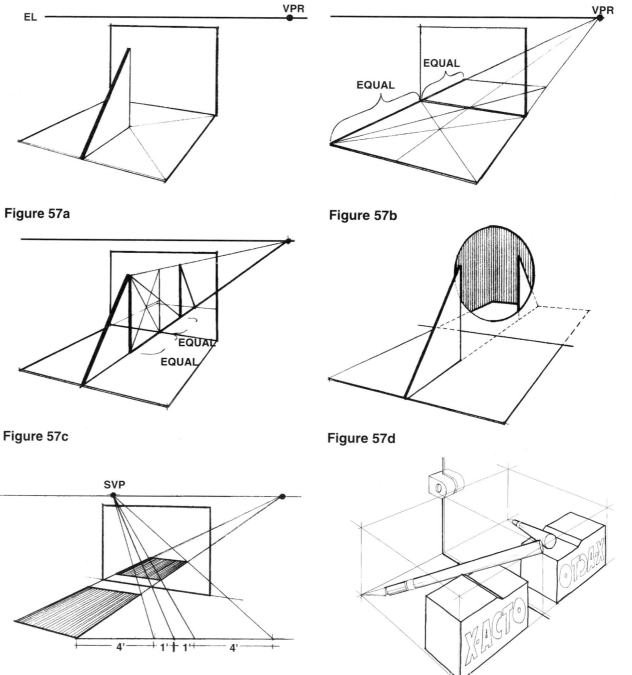

Figure 57a

Figure 57b

Figure 57c

Figure 57d

Figure 57e

Figure 57f

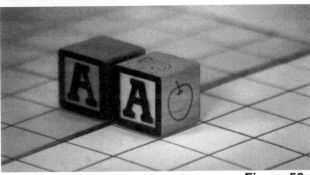

Figure 58a

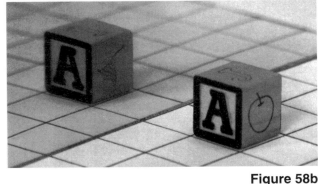

Figure 58b

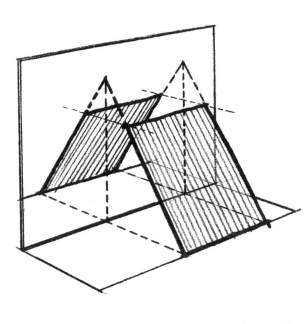

Figure 58c

Figure 58a
In this photograph one side of the block is touching the surface of the glass mirror. Observe the small space that exists between the block and its reflection. This is due to the glass thickness and the reflective coating being on the back side of the glass. Though not apparent in this photograph, this may also causes ghost images or double reflections. One image is reflected from the mirrored surface while a second less brilliant "ghost image" is reflected from the surface of the glass.

The small space between the object and image is usually ignored during perspective construction. Any adjustments for the slight discrepancy are estimated after construction is completed. Front surfaced mirrors, such as chromed metal, will not show any space between the point touching the mirror and its reflection.

Figure 58b
Compare this photograph with Figure 58a. As the object is moved farther from the surface of the mirror, its reflection appears to move behind the mirror an equal distance.

Figure 58c
When a line is at an acute angle to the mirror, the line and its reflection make equal angles with the plane of the mirror. If extended they will intersect the mirror, as if the object were leaning against the mirror's surface.

Figure 58d
The reflection of more complex forms can be drawn by locating the reflection of a simpler shape which outlines the form. In this instance the reflection was constructed for the grid. The letter was plotted on the grid with the image reversed.

Exercise:
Place tracing paper over Figures 58a and 58b. Draw the construction lines necessary to locate the reflection of the blocks. Once completed, repeat this procedure with four other selected photographs of reflected objects. Select an example of a horizontal, vertical, diagonal and curved reflective surface.

Procedure:
1. Neatly cut out each photographic example and mount it on a piece of 11"X14" white drawing paper.
2. Tape a piece of tracing paper over each photograph and draw the construction lines necessary to locate several key points of the reflected object.

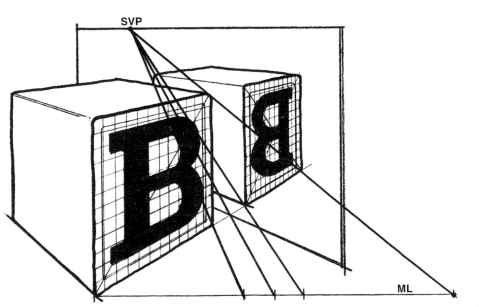

Figure 58d

DIAGONAL MIRRORS

The examples on this page were taken from a photograph and confirm certain perspective construction procedures used for diagonal mirrors. Page 60 includes a more complete step by step procedure for constructing a simple reflection into a diagonal mirror.

Figure 59a

This diagram is a side view of the illustration in Figure 59b. Mechanical construction of a diagonal reflection requires first laying out the object, mirror and reflection in a side view such as this.

Figure 59b

A line drawn from any point on the object to its reflection is perpendicular to the diagonal mirror surface. The dashed lines are perpendicular to the tilted mirror and as such converge on a common auxiliary vanishing point above the eye level. In this case the auxiliary vanishing point is above vanishing point left.

The brackets show that the lengths of the dashed line in front and behind the mirror are equal. This reinforces the theory that applies to all reflections: "The reflection of an object appears to be the same distance behind the mirror as the object is in front of the mirror." Note that lines parallel to the mirror are reflected parallel to the mirror and converge on the same vanishing point, in this case vanishing point right.

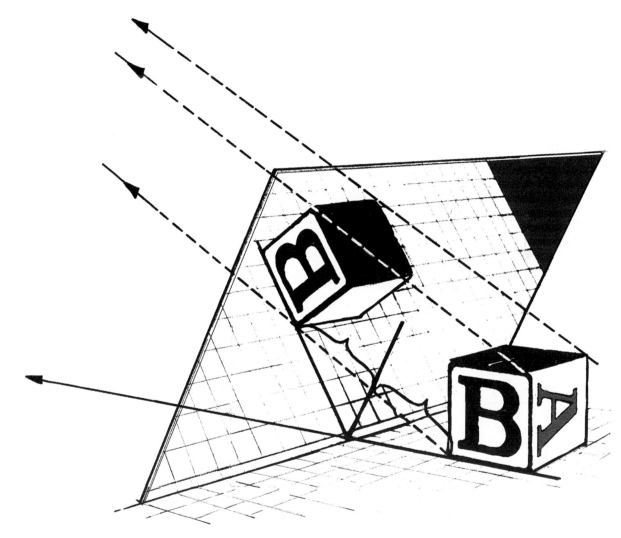

Figure 59b

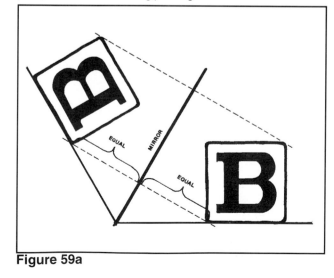

Figure 59a

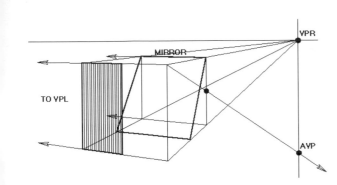

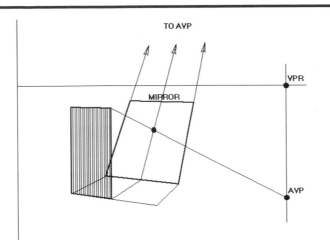

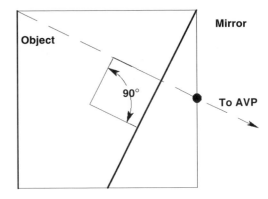

Figure 60a

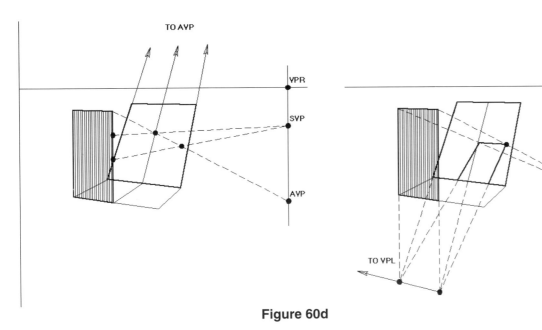

Figure 60b

Figure 60c

Figure 60d

Figure 60e

Figure 60a
This side view information is used to draw the object in relation to the mirror and locate the auxiliary vanishing point for lines perpendicular to the mirror in perspective.

Figure 60b
Here the object and mirror are constructed to scale within a four inch cube that is positioned five inches below the eye level. The information from Figure 60a is used to find the auxiliary vanishing point for lines that are perpendicular to the mirror's surface.

Figure 60c
A point on the mirror's surface is found by projecting from the top right corner of the object, perpendicular to the mirror's surface, to the auxiliary vanishing point. This point is essential for determining the distance from the corner to the mirror.

Figure 60d
The special vanishing point method is used to duplicate the distance from the mirror, behind the mirror's surface. The front edge of the object serves as a measuring line.

Figure 60e
Once the reflection for the top front corner of the object is located, the remainder of the reflected image is constructed. This is done by extending the verticals of the object downward. The edge and center of the mirror are extended downward until they intersect the extended plane of the mirror. The reflection of the sides extend from the reflected top corners downward to the points below the mirror.

MULTIPLE REFLECTIONS

One of the more interesting visual phenomena is the multiple reflection. The confusion caused by the endless reflections in a house of mirrors and the beauty of a kaleidoscope are both dependent on multiple reflections. All reflections are based on the concept that the angle of incident equals the angle of reflection. Therefore, if two mirrors are 90° to each other a series of 90° reflections will occur. Should the angle between the mirrors be 60° so will the reflections.

Another rule is that the total of the original angle and all of the reflections is always 360°. Consequently, mirrors at 90° have three reflections. (Three times 90° plus the original 90° equals 360°.) Mirrors at 60° have five reflections and so on. When the angle between the mirrors is not evenly divisible into 360°, the remainder would appear as a fragment of an additional image midway in the reflection.

Figure 61a

This multiple image reflection contains three mirrors, all perpendicular to one another: two vertical and one horizontal mirror which are joined much like the inside corner of a box. The child's block shown in heavy line is the only object; all of the other images are reflections. These images remain aligned, creating somewhat of an optical illusion. The reflected images seem to pass from one mirror's surface to another without changing direction. This is caused by the alignment of the various reflections.

Construction methods for this example and the others on this page are outlined on the previous pages. When drawing the reflections of reflections, remember that the image does not appear to be on the surface of the mirror, rather it seems to be the same distance behind the mirror as the object is in front of the mirror. In other words, assume that each subsequent reflection is a real object existing behind the mirror's surface then proceed as usual.

Figures 61b and 61c

These sketches show the effect of changing the angle between two mirrors. When drawing such examples consider one mirror at a time and continue to find the reflections until the "circle" is complete. Observe that the total of the mirror's angle and reflections always equals 360°. In Figure 61c the angle cannot be divided evenly into 360°. As a result this causes the fragmentation of the middle image in order to include the remaining 10°, for a total of 360°.

Figure 61a

Figure 61b

Figure 61c

CURVED MIRRORS

The reflections on curved surfaces are subject to the same laws of optics that govern any reflection; however complexity and distortion of the curved surfaces make mechanical construction difficult. Locating lines perpendicular to the surface of a curved mirror can be most time-consuming. In addition, curved surfaces reflect more of the environment than we can see within our normal cone of vision. This further complicates the task of constructing the reflection.

The simplest way to draw reflections in curved mirrors seems to be from life. This is not to say that structural issues should be disregarded. Rather, structure should be used to determine a few critical points, then the remainder of the reflection can be drawn freehand from life. Recalling the procedures regarding flat mirrors will aid in maintaining realism even in the roughest sketch, especially when a model is not available.

Figure 62b

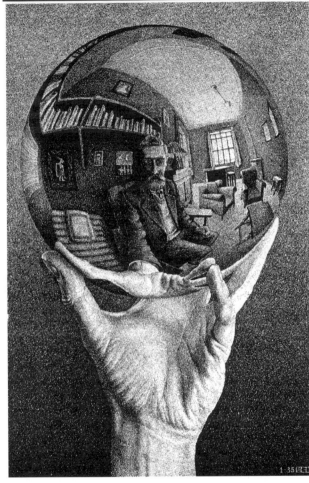

Figure 62a

Figure 62c

Figure 62a
This self portrait by M. C. Escher was drawn from life. It includes an extremely distorted reflection of almost the entire room. The spherical reflection is like a photographic image taken with a fish-eye lens.

Figure 62b
It is evident in this still life that the reflection of the pen does not appear to wrap around the surface of the sphere. The reflection seems to twist back into the spherical mirror. This is due to the variable distance from points along the pen to the sphere's surface. As in any reflection, the distance from a point on the object to the mirror is equal to the apparent distance from the surface of the mirror back to the reflection.

Figure 62c
This figure demonstrates the complexity of compound curved reflections, even in the simple geometric forms of a sphere, cone and cylinder. The application of three dimensional computer modeling simulates the curved reflections as they would appear in reality. Such tools represent an aid to the artist's ability to visualize complex subject matter.

TYPES OF SHADOWS

For purposes of perspective study, the subject of shadows is divided into two categories: shadows cast by sunlight and shadows cast by artificial light sources such as a light bulb or candle. Differences in their respective shadows require slightly different drawing procedures. However, many aspects of sunlight and artificial light shadows are similar. The basic difference between sunlight and artificial light is explained in the diagrams on this page.

In all shadow compositions, some planes will be in direct light while others will be turned away from the light and therefore are shaded. Shadows are cast only on surfaces facing the light by intervening objects. The shape of a shadow is determined by the form of the object and the contour of the surface on which the shadow is cast. This shade line is actually the boundary that separates portions of the object which are in light from portions in shade. This boundary or shade line forms the outline of the shadow on the surface facing the light.

Figure 63a

Sunlight rays are assumed to be parallel due to the extreme distance between the earth and the sun. As with any light source the rays from the sun radiate outward from their source. The angle at which they radiate is relatively small compared to the distance they travel to the earth's surface. This drawing, which is not to scale, shows that the radiation of the sun's light striking the earth is so minimal that the rays of light can be considered parallel. The rays of light travel in straight lines and conform to the general rules of perspective governing all parallel lines. When the sun's direction is parallel to the picture plane the light rays remain truly parallel in the drawing. When the direction of the sun is receding or advancing, the rays of light converge at a common vanishing point on the eye level.

Figure 63b

Artificial light rays appear to radiate from their source more rapidly than those of the sun. This is apparent in the shadows because of the relatively close proximity of the light source to the intervening objects. The resulting shadows differ from those cast by sunlight in that they become larger as they radiate from the light source.

Figures 63c and 63d

The sunlight shadow of the table in Figure 63c is the same size as the table top. However the artificial light shadow in Figure 63d radiates from an artificial light source and as a result becomes much larger than the actual table top.

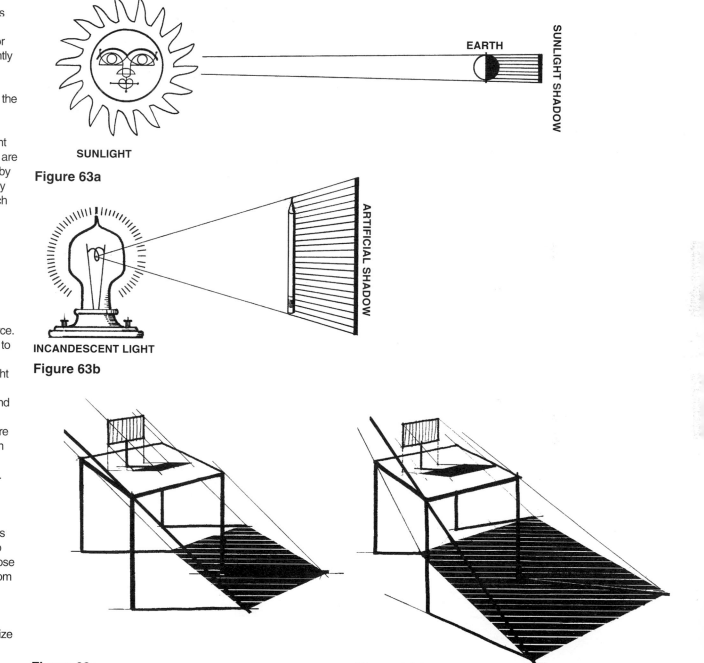

SUNLIGHT

EARTH

SUNLIGHT SHADOW

Figure 63a

ARTIFICIAL SHADOW

INCANDESCENT LIGHT

Figure 63b

Figure 63c

Figure 63d

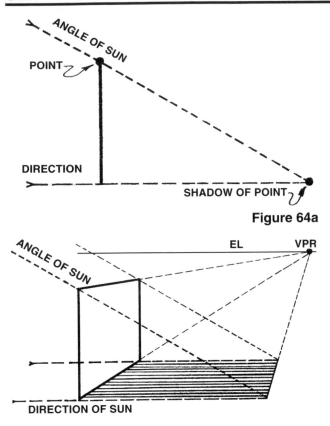

Figure 64a

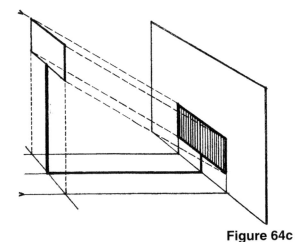

Figure 64c

LIGHT RAYS PARALLEL TO THE PICTURE PLANE

Types of sunlight shadows are grouped according to the direction of the light rays in relationship to the picture plane. Pages 64 through 66 cover sunlight rays that are parallel to the picture plane. As with any lines parallel to the picture plane, these light rays are not foreshortened and do not require the use of a vanishing point. On this page the angle of the sun to the ground and eye level is established as 30°. This angle can be measured with a triangle or protractor because the angles are not foreshortened.

Figure 64a

This drawing illustrates several important principles relevant to sunlight shadows. In this instance a shadow is cast for a pole that is standing vertical to the ground plane.

Locating the shadow of any object is dependent upon finding the shadow for points of the object. The artist must first find the angle and direction of the sun's rays. The angle of the sun is represented by an **angle line** that is projected through the point that is to cast a shadow. The direction is indicated by a **direction line** drawn through the point on the ground plane, directly below the point casting the shadow. The intersection of these two lines is the location of the cast shadow for the point.

The angle of the sun is determined by the height of the sun in relationship to the ground plane and eye level. The higher the sun is above the eye level, the greater the angle and shorter the shadow. The lower the sun, the smaller the angle and longer the shadow.

The direction of the sun is actually the angle of the sun to the picture plane. In the case of parallel sunlight shadows, the direction of the light is parallel to the picture plane, coming from the left or right. Direction lines are drawn on any horizontal planes on which an object sits and a shadow is cast. These horizontal planes are referred to as common ground.

Figure 64b

This is a drawing of a vertical plane casting a parallel sunlight shadow at 30° to the ground plane. The following procedure explains the steps required to complete this drawing.

1. Construct a vertical plane that converges on vanishing point right.
2. Draw the angle of the sun at 30° through the top corners of the plane.
3. Establish the direction of the sun by drawing horizontal parallel lines through the points on the ground directly below the top corners.
4. The intersections of the direction line and angle line for each point establish the shadow for each top corner on the ground plane.
5. To complete the shadow, connect the shadow of both top corners with a straight line. This is the shadow of the top of the plane. The shadows for the vertical edges are drawn by connecting the shadows for the top corners with the bottom corners of the plane. The vertical sides cast shadows on the ground plane that are parallel to the direction of the sun. This is true of all vertical edges that cast shadows in sunlight compositions.

Figure 64c

The shape of any shadow is affected by the surface on which it is cast. Here the shadow of the sign is interrupted by a vertical wall. Shadows of vertical lines cast onto vertical surfaces will always be vertical. The sign and its shadow on the wall are parallel because the sign itself is parallel to the wall. Vertical reference lines were added to facilitate locating the shadow of the sign's corners. All shadow problems must be reduced to locating the shadows of points on vertical lines.

Figure 64d

Here the sign is no longer parallel to the vertical wall. As a result, the shadows of the horizontal edges no longer converge at the same vanishing point as the sign. The shadows for the individual corners of the sign must be located. Then these are connected in sequence to complete the sign.

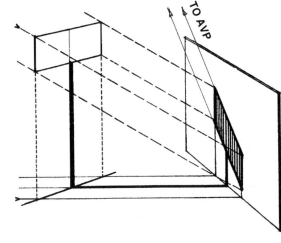

Figure 64d

Figures 65a and 65b

In both of these examples, only a portion of the sign's shadow occurs on the wall. In such instances the best approach is to first locate the complete shadow on the ground plane as if the intervening object did not exist. Then locate the shadow on the wall, imagining the wall extended as large as necessary to contain the complete shadow. Finally, darken the respective portion on the shadow on the ground and wall. The same procedure applies whether the object is parallel to the wall as in Figure 65a or is at an angle to the wall as in Figure 65b.

Figure 65c

The shadow of the pole is interrupted by an inclined surface which is not vertical to the ground plane. The shadow of the pole is neither vertical nor parallel with the sides of ramp. The first step is to locate the direction line on the common ground which determines where the shadow intersects the bottom of the ramp. Next the direction line is extended vertically up the back vertical wall of the ramp to the top edge. Finally the direction line is drawn across the incline connecting the top back edge with the front bottom edge. This establishes the direction of the shadow on the inclined surface.

To complete the shadow for the pole cast upon the incline, an angle line is projected through the top of the pole. The intersection of the angle line and the direction line on the inclined surface establishes the shadow for the top of the pole. The shadow for the pole is drawn from the base of the pole to the incline, then follows the direction line across the incline to the established point.

Figure 65d

In this example the intervening surface is a compound curve. Regardless of the complexity of the subject, the construction drawing is always simplified to locating the shadow of vertical lines on either horizontal or vertical planes. Several imaginary vertical planes have been inserted along the curved surface at critical locations. The direction line is extended up each vertical surface to the curved surface, thus establishing a point on that surface. A curved direction line is constructed by connecting the established points freehand, approximating the curve of the surface. Note that the more planes inserted, the more accurate the resulting shadow will be. Once again the shadow is completed by finding the intersection of the angle line and the direction line.

Exercise:

Select photographic examples with the sun parallel to the picture plane, the sun in front of the viewer and the sun behind the viewer. Determine the sun's location in each photograph.

Procedure:

1. Neatly mount each photograph on a piece of 11"X14" white drawing paper. Overlay each with tracing paper.
2. Find the location of the sun by connecting selected points on the object with their shadows.
3. Draw the necessary construction to show the angle and direction of the sun. Label the type of sunlight shadows.

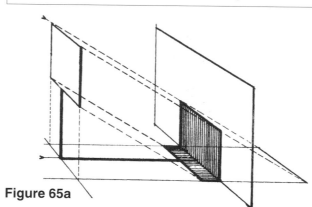

Figure 65a

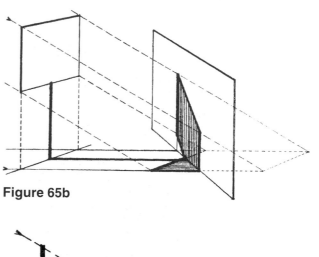

Figure 65b

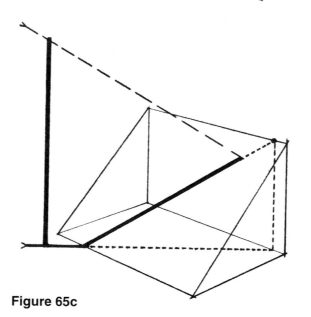

Figure 65c

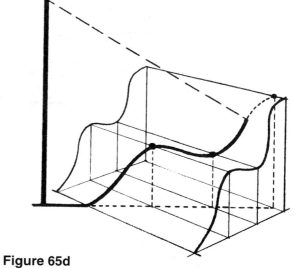

Figure 65d

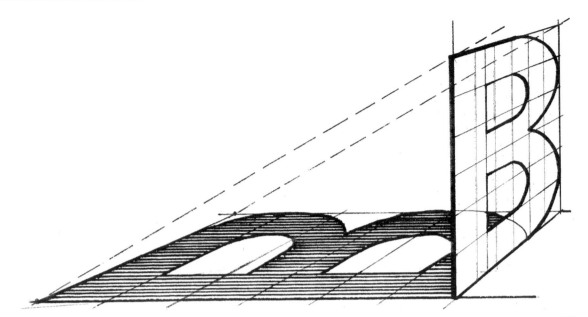

Figure 66a

Figure 66a
The procedure shown here is typical of that used for more complex objects. Rather that plotting the shadow for many points along the curved form, only the shadow of the square containing the form is located. This requires finding the shadow of only two points of the square, and estimating the form within its perimeter. To ensure greater accuracy, the shadows of a few important points can be constructed. The shadows of the most complex subjects can be found using this procedure.

Figure 66b
The shadow of this cylinder requires locating the shadow of the top rim. The shadows of a few random points along the circumference of the top are found first. Then a smooth ellipse is estimated between the established points. The shadow of the vertical sides is determined by drawing lines parallel to the direction of the sun and tangent to the base of the cylinder.

Figure 66c
In this interesting student example, the sun is parallel to the picture plane and at a 60° angle to the eye level. The shadow of every corner on the table was located separately, then connected to complete the shadow. Note that the shadow converges on the same vanishing point right as the table. The shadows of the vertical lines remain parallel to the picture plane.

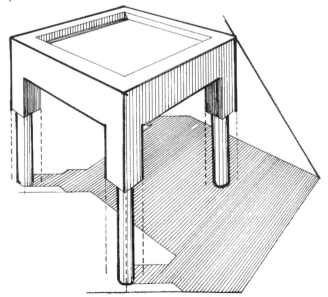

Figure 66b

Figure 66c

LIGHT RAYS NOT PARALLEL TO THE PICTURE PLANE

In all of the previous shadow examples, the direction of the sun has been parallel to the picture plane. However, the direction of the sun may be any angle to the picture plane depending on the direction the viewer is facing.

The sun's rays appear to converge when they are not parallel to the picture plane. Two vanishing points are needed to establish the angle and direction of the sun. The location of the sun's vanishing point along the eye level determines the direction of the sun. The angle of the sun is determined by the height of an auxiliary vanishing point. When the sun is shining toward the picture plane or onto the face of the viewer, the auxiliary vanishing point will always be above eye level. When the sun is shining away from the picture plane or onto the viewer's back, the auxiliary vanishing point will be below eye level.

SUNLIGHT RAYS TOWARD THE PICTURE PLANE

In the examples on pages 67 and 68, the direction of the sun is toward the picture plane. The methods for constructing sunlight shadows toward the picture plane are provided below.

Figure 67a

1. Establish a normal eye level and draw the sign and post.
2. Determine the desired direction of the sun by visualizing the intended position of a shadow for a vertical of the sign.
3. Project from the imagined shadow of the vertical back through the point on the ground until it intersects with the eye level. This locates the sun's vanishing point, S'VP on the eye level. You can control the direction of the shadow by moving the sun's vanishing point along the eye level.
4. To determine the angle of the sun, draw a vertical line up from the S'VP. Locate the auxiliary vanishing point on this line by projecting from the imagined shadow through the point on the object casting the shadow. The intersection of this line and the vertical establishes the AVP or auxiliary vanishing point for the angle of the sun. The higher the AVP, the shorter the shadow.
5. Direction lines are drawn from the S'VP through the points on the ground plane, toward the picture plane. The angle lines are drawn from the AVP, through the point casting the shadow. The intersection of the direction and angle lines establishes the shadow for the corners.
6. The shadow is completed by connecting the shadow of each corner. The shadow is shaded using freehand lines that appear to converge toward the S'VP.

Figure 67b

This drawing depicts three signs with the shadows coming toward the viewer. The shadows of the vertical lines are actually parallel with one another but appear to converge at the sun's vanishing point on the eye level.

The center sign is parallel to the picture plane. The shadows cast by this sign's top and bottom edge are also parallel to the picture plane. On the left sign the receding horizontal lines and their shadows converge on the same vanishing point because the horizontal lines of the sign and the shadow are parallel. The triangular sign is also parallel to the picture plane. What observations can you make concerning the triangular sign and its shadow?

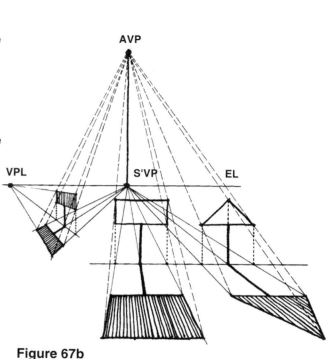

Figure 67b

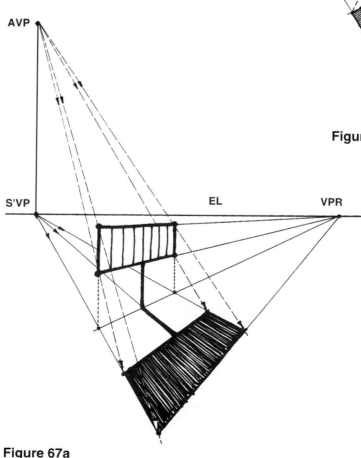

Figure 67a

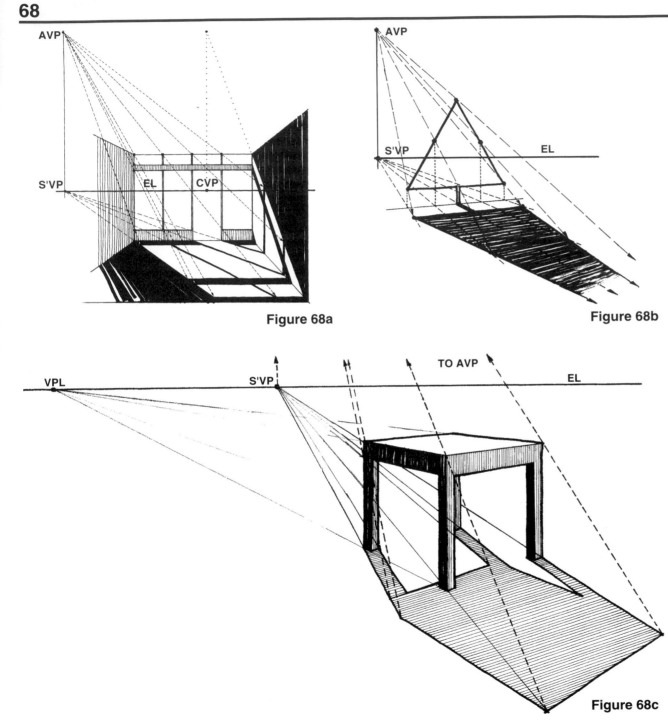

Figure 68a

Figure 68b

Figure 68c

Figure 68a
The sun is shining toward us through the back wall of this interior drawn in one point perspective. The shadows of the vertical window dividers radiate out from the sun's vanishing point on the eye level. The two window divider shadows which intersect the right hand interior wall continue vertically up the wall because the dividers are parallel to the wall. Conversely, the horizontal lines and their shadows on the floor remain parallel until the shadows intersect the wall. Note that if the diagonal shadow on the wall were extended beyond the wall, it would converge toward another auxiliary vanishing point above the central vanishing point.

Figure 68b
Here the shadow of the triangle extends beyond the frame of reference. Normally the shadow of the triangle's point would be used to construct the shadow of the triangle's sides. Since the shadow of the point is off the page, reference points are located along each side of the triangle. Shadows are then cast for these reference points. The shadow for the sides of the triangle is drawn by projecting a line from the shadow of the bottom corners, through the reference point shadows. This determines the direction of the shadow for the triangle's sides. Whenever the shadow of a critical point falls off the page, the reference point technique can be used to construct the portion of the shadow that appears on the page.

Figure 68c
The shadow cast by the table comes toward the viewer because the direction of the sun is toward the picture plane. The sun's vanishing point is on the eye level and the auxiliary vanishing point is above the eye level, beyond the frame of reference. The solid horizontal lines converge at the sun's vanishing point. They represent the direction of the sun. The dashed lines represent the angle of the sun and they converge toward the auxiliary vanishing point.

The shadow of the entire table was found by locating the shadows of the four top corners. In addition, a shadow was found for the intersection of the table skirt and the left leg. From this point, the shadow for the bottom edge of the skirt was drawn using vanishing point right. Note that the skirt of the table and the shadow converge on the same vanishing point because they are parallel receding lines. The same procedure was used to construct the remaining shadow for the table skirt.

SUNLIGHT RAYS AWAY FROM THE PICTURE PLANE

In all the examples on pages 69 and 70, the direction of the sun is away from the viewer's picture plane. In contrast to the two previous pages, the shadows here recede back into the picture, away from the viewer. The auxiliary vanishing point for the angle of the sun is below the eye level and the sun does not appear in the picture.

Figure 69a

This illustration shows the same object as in illustration 67a. The only difference is the sun is shining in the opposite direction. The drawing development can follow the same procedure as outlined for illustration 67a. The only significant difference in how the drawings are constructed is that here the auxiliary vanishing point used to determine the angle of the sun is now below the eye level.

Figure 69b

The shadow of the vertical panel recedes back toward the sun's vanishing point until it intersects the bottom of the block's side. The direction of the shadow runs vertically up the side until it reaches the top of the block, then continues back across the top toward the sun's vanishing point. The height of the horizontal plane has no effect on the direction of the shadow.

Figure 69c

Before the shadow of the board leaning against the wall can be drawn, the shadow of two imaginary vertical lines is found. These verticals are shown as dashed lines. Only the shadows of verticals recede toward the sun's vanishing point. First the shadows for the top of the imaginary verticals are located. The shadow of the diagonal panel is drawn along the ground toward them until it intersects the wall. At that point the shadow of the board angles upward to where the top of the board is touching the wall.

Figure 69d

The shadow of the tent is found by locating the shadow of the two tent poles, which are vertical lines. The shadow for the top of the tent is completed by connecting the shadows for the ends of the tent. Lines from each bottom corner of the tent are connected with the shadow for the top of the tent.

To find the shadow of the pole on the tent, connect the point where the pole's shadow meets the bottom of the tent with the point where an imaginary shadow on the vertical plane in the middle of the tent intersects the top of the tent.

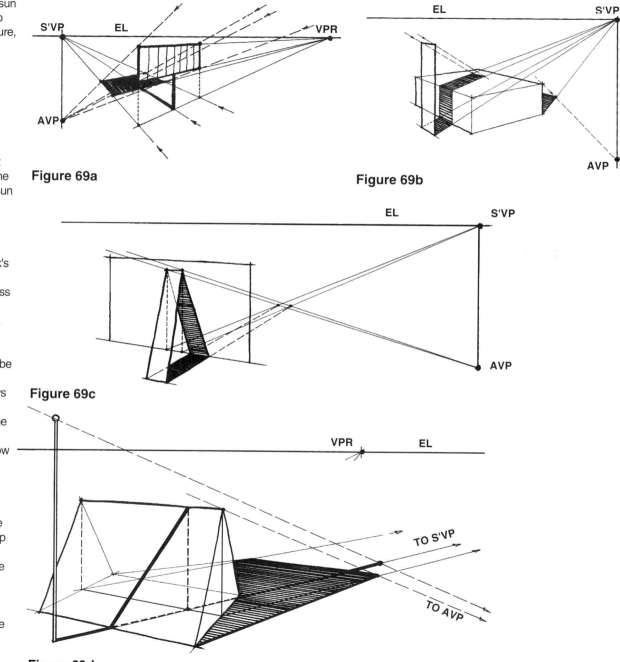

Figure 69a

Figure 69b

Figure 69c

Figure 69d

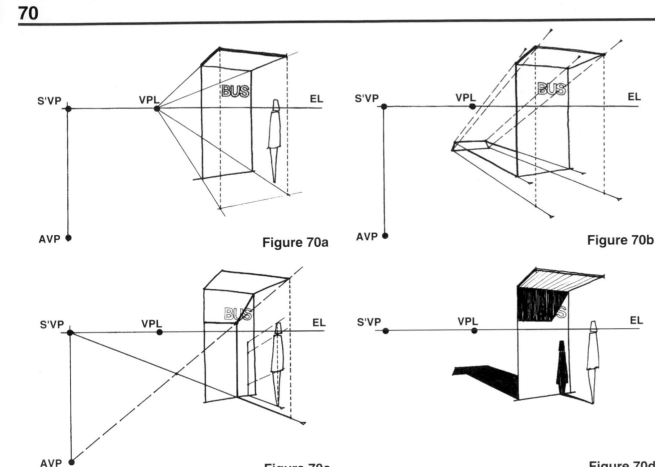

Figure 70a

Figure 70b

Figure 70c

Figure 70a through 70d
These four figures describe the sequence for drawing the shadow of the bus stop shelter

Figure 70a: The shelter is drawn from normal eye level. The direction and angle of the sun are established by locating the sun's vanishing point and the auxiliary vanishing point. Vertical construction lines are dropped from the two front corners of the roof and points are found where they intersect the ground. These two imaginary verticals will be used to locate the shadow of the roof.

Figure 70b: The shadows of the two vertical sides of the shelter and the two imaginary verticals are found on the ground. The tops of these shadows are also the shadow of the corners of the roof. The shadows of the four corners are connected and it can be seen that the shadow of the roof's outline is parallel to the sides of the roof itself.

Figure 70c: The shadow of the roof's right front corner is found on the back wall of the shelter. Again, the imaginary vertical is used as reference. Starting at the intersection of the right side of the roof and the back wall, the shadow of the roof's right side goes diagonally down the wall until it meets the shadow of the right front corner of the roof. From there the shadow moves along the wall parallel to the front edge of the roof. Another imaginary vertical is drawn through the figure and used to position the person's shadow on the wall.

Figure 70d: The shadow is completed by filling in the outline of the shadows.

Figures 70e and 70f
In these figures only the angle of the sun has been changed. The auxiliary vanishing point is located below the frame of reference. This causes the shadows of the verticals to be much shorter and the shadow of the roof extends to the ground.

The first step is to locate the shadow of the four corners of the roof on the ground. Where the shadow of the right side of the roof intersects the base of the wall is the point at which the shadow begins a diagonal path up the wall. The diagonal runs to the intersection of the right side of the roof and the back wall. Again the outline is filled in, completing the shadow.

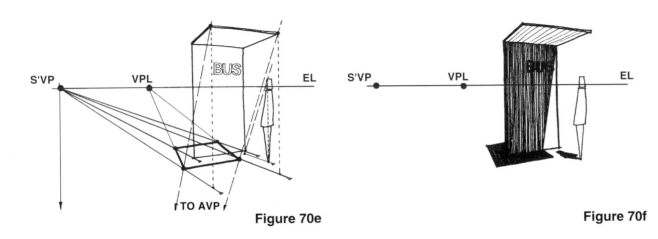

Figure 70d

Figure 70e

Figure 70f

Surely everyone at one time in his or her childhood has been entertained, if not frightened, by the projection of huge shadows on a wall. This ability to project shadows much larger than the original object is a unique aspect of artificial light. Sunlight shadows, in contrast, remain virtually the same size as the object casting the shadow.

The increase of shadow size is due to the nature of artificial light sources. Most light sources, for the sake of perspective drawing, radiate light from a single point source. It is this radiating characteristic that produces the increase in the size of artificial light shadows.

To accurately depict a realistic shadow, the artist must determine the particular type of light source involved. Various types of light sources have unique characteristics which can notably affect the resulting shadows. As an example, a candle or clear incandescent lamp can be considered a pinpoint source of light and cast relatively sharp defined shadows. However, a fluorescent lamp radiates light from a large area and casts more subtle shadows. Other considerations such as reflectors, multiple light sources, and diffusers all contribute to softening the edge of the shadow and in extreme cases may eliminate the shadow altogether.

The following construction information is based on the light radiating from a pinpoint source. Once the basic principles of shadow construction are understood, they can be applied to more complex lighting situations.

Figure 71a

This diagram identifies all of the terminology used in the subsequent shadow drawings. Try to think of even the most complex drawing in terms of this basic diagram. The reference point beneath the light is located on the common ground. Common ground refers to the surface on which the objects are located. The common ground may be the floor, a table, shelf or even the ceiling when drawing shadows of hanging objects. To find the reference point a line is drawn from the light source, perpendicular to the surface of the common ground.

Figure 71b

In this example, four posts are drawn positioned around an artificial light source. The posts are two feet tall and positioned on the ground plane. The light source is hanging five feet above the ground. The procedure for drawing the shadows of the posts is as follows.

1. Drop a five foot vertical measuring line from the eye level. Locate the light source on top of this line and a reference point is placed at the bottom of the line.
2. Draw the four vertical posts. Use the vertical measuring line to establish the height of each post.
3. Radiate lines from the light's reference point on the ground through the base of each vertical. This determines the direction of the shadows.
4. Draw lines from the light source through the top of each post. The resulting angles determine the length of the shadows. The shadow of the top of the post is established where the angle line intersects the direction line for each post.
5. The shadows are completed by darkening the direction line from the base to the shadow of the top of each post.

Note:
The shadows of the vertical lines all radiate out from the lights reference point on the ground plane.

Exercise:
Look for photographic examples which include cast shadows from an artificial light source. Select three of the best examples and mount them on 11"X14" drawing paper. Analyze the objects and shadows in each photograph.

Procedure:
1. Place a sheet of tracing over each of the mounted photographs.
2. Draw lines over the photograph from the light source, through a few critical points on the object, to the shadow of each point.
3. Locate the reference point, RP for the light source on the common ground for the objects.
4. Draw lines from the reference point through the points on the ground below the chosen critical points to confirm the direction of the shadows.

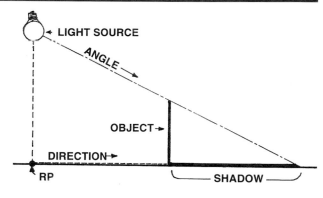

Figure 71a

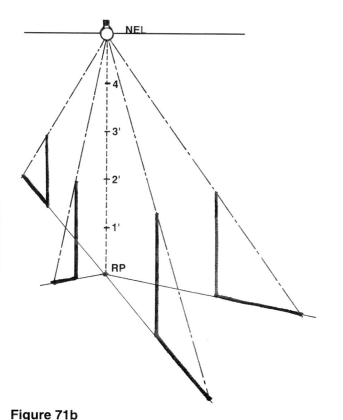

Figure 71b

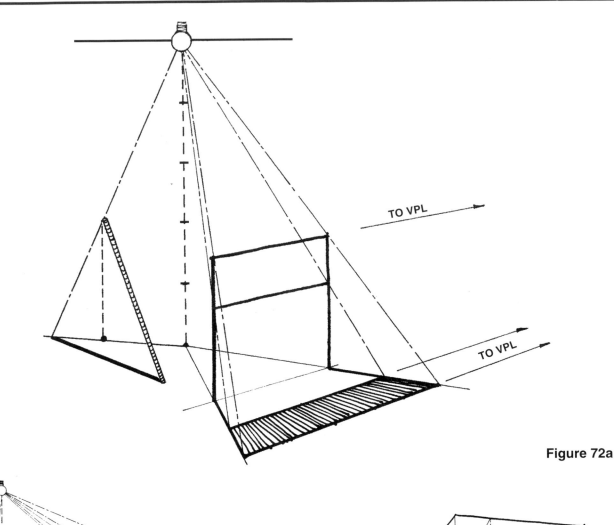

TO VPL

TO VPL

Figure 72a

Figure 72a

The procedures outlined on the previous page apply to the construction of all artificial light shadows. Here the shadow of the horizontal sign is parallel to the sign. As with sunlight shadows, whenever a line is parallel with the surface on which its shadow is cast, the shadow will be parallel to the line. Because of this, the sign and its shadow both converge toward the same vanishing point.

To find the shadow for the diagonal pole it is necessary to first find the point on the common ground, directly below the top of the pole. This is done by projecting an imaginary vertical line from the top of the pole downward. This example might serve as a reminder that essentially construction of all shadows begins with finding the shadow of vertical lines.

Figure 72b

The shadow of the pole radiates out from the reference point beneath the light then becomes parallel to the pole as it moves vertically up the side of the box. Note the dashed lines which are used to determine the direction of the shadow across the top of the box. The shadow of the small vertical card is found by establishing a second reference point beneath the light, at the same height as the box top.

Figure 72c

This figure explains how to determine the direction of a shadow when it is cast on a diagonal surface. The shadow for the panel sides intersects the base of the ramp. A vertical construction line is located on the back vertical wall of the ramp. The sides of the shadow are drawn to the top of the ramp where the lines on the back vertical wall intersect the top of the ramp.

The shadow of the top corners of the panel are found by drawing rays from the light source through the top corners of the panel until they intersect the shadow of the sides on the ramp.

The top of the shadow recedes to vanishing point left because the top edge of the panel is parallel to the ramp. Also, the shadow increases in size as it moves up the ramp because the shadow is becoming farther from the light source.

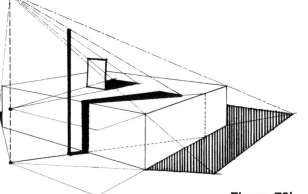

Figure 72b

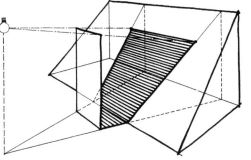

Figure 72c

Figure 73a

In this drawing the top shelf is above the light source and consequently part of the shadow is cast on the ceiling. A reference point, found on the ceiling above the light, is used to construct the shadow of the top shelf.

If you turn the page upside down the floor becomes the ceiling and illustrates that the principles of shadow construction remain unchanged regardless of the location of the common ground. In fact, turn the page sideways and note how the point on the wall, perpendicular to the light source, could have been used as a reference point beneath the light source. In this drawing the reference point on the wall can be used to check the direction of the shadows of the shelves' sides.

Figure 73b

Drawing the shadow of this curved surface can be done by locating the shadows of several points along the curve. The shadows of five points along the curve are found on the ground, then a smooth curve is drawn through these shadows to complete the shadow of the curved edge.

Drawing shadows of any complex form is a matter of finding the shadow of several vertical lines at critical points on the surface of the form. These shadow points are then connected to form the shadow of the more complex shape.

Figure 73c

Drawing shadows cast by two or more lights in the same picture is done by finding one shadow at a time. The shadow areas which overlap will be the darkest. Factors such as the intensity of the lights and their relative distance from the subject must be considered when determining the sharpness and value of each shadow.

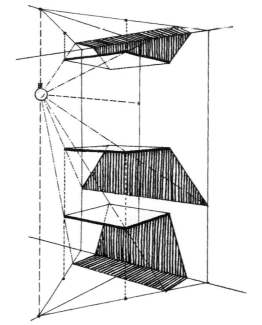

Figure 73a

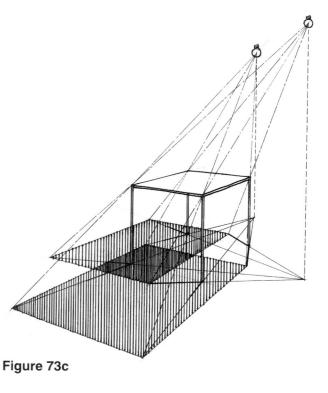

Figure 73c

Figure 73b

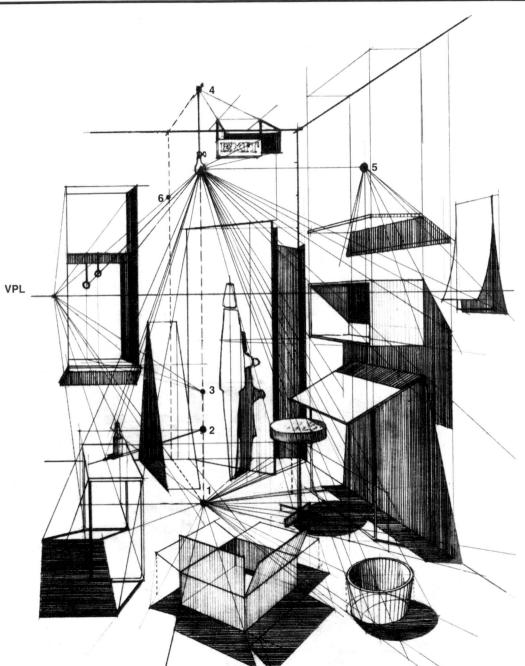

Figure 74a

In this interior layout or construction drawing the light source is suspended on a two foot cord attached to the ceiling about two feet from the back wall. It is best to position the light source where it will create the best shadow results. A few quick construction lines drawn early in the drawing will reveal the general shape of the final shadows. This allows the artist the opportunity to slightly reposition the light as necessary to improve the shadow composition.

Here six reference points were used to find the direction of the shadows across six different common ground planes from the floor to the ceiling. Point one was established for all shadows that share the floor as common ground. Points two and three are in mid air, with point two being used for the table top and point three for the shadow on the window sill. Point four is used for the shadows on the ceiling, while points five and six are for shadows at several locations on the walls. This may seem a bit confusing but it is best approached one shadow at a time, establishing references points as needed.

The number of shadows in this drawing may seem perplexing at first. However, each shadow was found in turn by locating shadows of vertical lines drawn through critical points on the objects. In summary, to draw the shadow of any subject, no matter how complex, it is simply a matter of finding shadows of key points on the subject. This is true whether the shadow is produced by sunlight or artificial light. The shadow of any point is found by drawing a vertical line through the point to the common ground. Then the shadow of that vertical line is constructed using a direction line and an angle line that intersect, establishing the shadow of the point in question. Finally, points are connected in sequence to form the outline of the shadow and the shadow is filled in.

VPL

Figure 74a

The only primary and unique characteristic of three point perspective is that the picture plane is tilted in relation to the subject. The tilted picture plane causes the vertical lines to become foreshortened and therefore converge at a common vanishing point. The vanishing point for the verticals is called vanishing point three and is always located above or below the eye level on a vertical line drawn through the central vanishing point. Review pages 15 through 18 for the definition of three point perspective.

As we view our environment, we rarely keep the picture plane vertical to the ground. To do so requires that we look straight at the horizon or eye level despite the location of our subject. To draw in this manner may result in an unrealistic composition or lead to extreme distortion of the subject. Most often when we look at a subject we are tilting the picture plane slightly, creating a more natural point of view. As the picture plane is tilted to view a subject, the cone of vision tilts and distortion of the subject is minimized.

Three point perspective offers the most dynamic view of a subject. It is a valuable asset in creating the exciting imagery often seen in advertising illustrations. In addition, three point perspective allows the artist to depict objects as they are normally seen. Looking up at, or down from, a tall building requires three point perspective as do aerial views from an airplane. Small objects or low furniture are also commonly viewed with the picture plane tipped. Dynamic expression and greater realism are both possible with three point perspective.

Figures 75a through 75d
These figures show the effect of tilting the picture plane at various angles. Notice that the central ray of vision is always perpendicular to the picture plane. The vertical lines of the cube are no longer parallel to the picture plane and converge at vanishing point three. In Figures 75a through 75c the viewer looks down at a progressively steeper angle causing greater foreshortening of the verticals. In Figure 75d the picture plane is tilted in the opposite direction as the viewer looks up at the cube. The verticals now converge at a third vanishing point that is located above the eye level.

By comparison, it is apparent that the more the picture plane is tipped, the greater the verticals are foreshortened. In a drawing this vertical foreshortening is controlled by placement of the third vanishing point. Locating vanishing point three far above or below eye level would indicate that the picture plane is tilted only slightly. The convergence of the verticals may be barely detectable. The other extreme would be to locate the third vanishing point almost on the eye level. In this case the picture plane would be tipped almost horizontal. Vanishing point three would be practically in front of the station point resulting in dramatic foreshortening and convergence of the verticals.

Figure 75e
An infinite number of the same size cubes are formed using only three vanishing points. Observe that all of the verticals are parallel to one another and converge to the same vanishing point three. Note that the cube in the upper right corner is slightly distorted as a result of moving beyond the cone of vision.

Figure 75e

Figure 75a

Figure 75b

Figure 75c

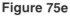

Figure 75d

Figure 76a **Figure 76b** **Figure 76c**

MEASURING IN THREE POINT PERSPECTIVE

In three point perspective all vertical lines are foreshortened and cannot be measured with a ruler. However, perspective measurements can be made along any vertical in three point perspective using a version of the special vanishing point method. (See pages 35 and 36.)

Figures 76a, 76b and 76c

These photographs are in three point perspective and were taken from the same eye level. The camera and therefore the picture plane are tilted at a greater angle for each successive photograph. Note how the verticals are more foreshortened as the picture plane is tilted.

Exercise:

Use Figures 76d and 76e as a guide to draw the three point perspective cube.
Use 11"X14" drawing paper or larger.
Use a normal eye level.
Construct a three foot cube.

Procedure:

1. Establish the eye level and CVP. Locate VPL three times as far from the CVP as VPR.
2. Draw a vertical line through the CVP and place vanishing point three on this vertical line. The farther below eye level VP3 is located will result in less foreshortened verticals.
3. To determine the distance below eye level, estimate the five foot height along the vertical. This measurement is somewhat arbitrary. However, it should be within the cone of vision. Label this measurement 0'.
4. Connect VPR with VP3 to form a diagonal line called the right wall horizon. Note that though VPL could be used, however in this case it was most convenient to use VPR.
5. Draw a measuring line from the CVP, parallel to the right wall horizon, and divide the line into five equal measures. This line is parallel to the tilted picture plane and can be measured with a ruler.
6. Draw a line through both 0' marks to the right wall horizon. This establishes the SVP for measuring vertically.
7. Measurements are transferred from the measuring line to the foreshortened vertical using the SVP.
8. As shown in Figure 76e darken the front vertical of the cube from the 0' mark to the 3' mark. Then draw receding lines from the ends of this line to VPL and VPR.
9. The depth of the cube is estimated as in two point perspective. Draw the verticals converging on VP3 and add the back lines of the cube to complete the structure.

Figure 76d

VPL NEL 5' CVP VPR

RIGHT WALL HORIZON

4'
4'
3'
3'
2'
2'
1'
1'
0'
0' SVP
0'

VP3

Figure 76e

VPL NEL 5' CVP VPR

3'

0'

VP3

Figure 77a

It is quite common in three point perspective for vanishing point three to be beyond the frame of reference. In this illustration two horizontal scales are used to maintain consistency in the receding verticals without actually locating vanishing point three, which is off the page.

The eye level is divided into equal spaces, numbered from the central vanishing point. A horizontal line is drawn near the bottom of the page and divided into the same number of equal spaces but using a smaller scale. The difference in the scales will determine the distance of VP3 from the EL. It is important that the 0 mark is directly below the central vanishing point.

Once the two scales are completed, any receding vertical line can be drawn simply by connecting corresponding numbers on both scales. If the line falls between marks, some visual judgment is required to keep the vertical aligned. This method can also be used for horizontal lines as well when vanishing point left or right falls well off the page.

Figure 77b

This preliminary drawing of a ten story building incorporates the special vanishing point method to divide the structure into ten equal floors. Two scales are used to align receding vertical lines as a substitute for vanishing point three. The sequence of construction is outlined in the following steps.

1. The eye level, VPL and VPR are established.
2. The eye level is divided into equal spaces from the CVP. A horizontal line is drawn across the top of the page and divided into the same number of smaller equal spaces.
3. The height of the building's front vertical cannot be measured with a ruler because it is foreshortened. First a distance of five feet is estimated below the eye level. This establishes the front bottom corner of the building.
4. A diagonal measuring line is drawn through the CVP, parallel to the left wall horizon.
5. This line is divided into ten equal spaces that represent one floor of the building or ten feet. The five foot mark must fall on the CVP.
6. A construction line is drawn from the front bottom corner of the building through the 0' mark on the measuring line. The intersection of this line and the left wall horizon is the location of the SVP.
7. Lines are drawn from each ten foot mark to the SVP. The established intersections determine the building height and divide the front edge of the building into ten floors.
8. The width of the building is estimated and various details are added in perspective to complete the structure.

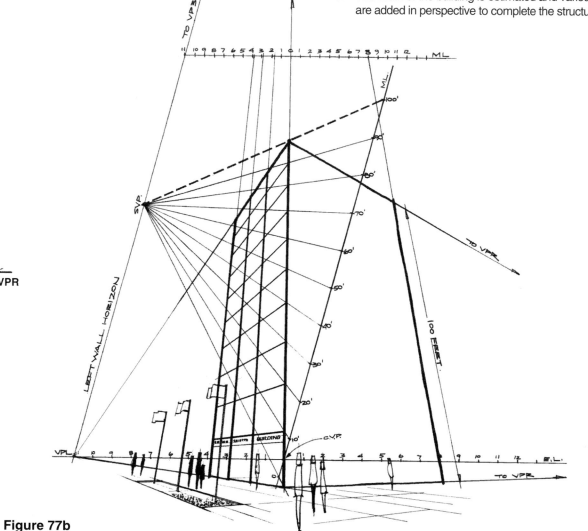

Figure 77a

Figure 77b

SHADOWS IN THREE POINT PERSPECTIVE

The procedures for drawing three point perspective shadows are virtually the same as used for two point perspective. The basic principles of shadow construction are explained on pages 63 through 74. Only a few aspects of drawing sunlight shadows in three point perspective differs from principles previously discussed. The following elaborates on these differences.

Figure 78a

In this example the direction of the sun is back into the picture. The vertical line on which the auxiliary vanishing point is located is drawn from the sun's vanishing point on the eye level to vanishing point three. All vertical lines, construction lines included, converge to the third vanishing point in three point perspective.

Figure 78b

This drawing is much like the previous figure except that the sun is in front of the viewer and consequently the shadow is coming towards the picture plane. Here the auxiliary vanishing point is above the eye level on the vertical line drawn from vanishing point three through the sun's vanishing point.

Figure 78c

When the direction of the sun is parallel to the picture plane but the angle of the sun is not, the auxiliary vanishing point for the angle of the sun is always located along a horizontal line drawn through vanishing point three.

Figure 78d

This cityscape depicts the application of sunlight shadows in three point perspective. The direction of the shadows is parallel to the picture plane. However, the angle of the sun is not. Note the distortion which occurs when the image extends beyond the normal cone of vision. The buildings appear to lean as the verticals converge towards vanishing point three. The distortion is intentional in this illustration, for the purpose of achieving a dramatic effect similar to that of a photograph taken through a fish-eye lens.

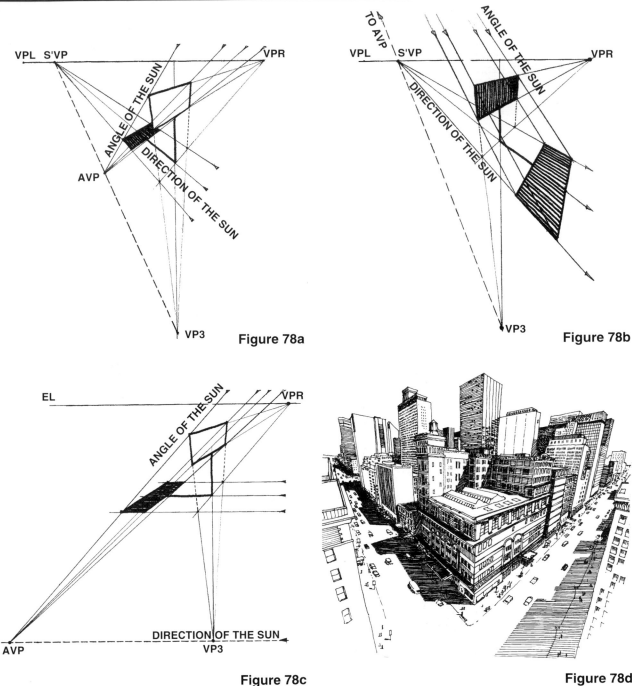

Figure 78a

Figure 78b

Figure 78c

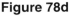

Figure 78d

The advent of computer graphics is having a profound impact on the artist's ability to communicate. The term *computer graphics* is used to describe a wide variety of images from flat graphic shapes to sophisticated three dimensional models and renderings. Many of the computer imaging software programs include features that assist the artist in visualizing the subject in space. The principles of optics and perspective drawing have been adapted to this rapidly developing medium. Advantages to using such systems include accuracy, flexibility and speed.

The use of computer graphics represents a shift in methods which afford the artist greater control of the subject. The new technology allows the artist to control color and lighting, reflection, texture and pattern as well as the perspective characteristics of the subject. Once a subject is constructed it can be viewed rapidly from a variety of locations in real time. Illustrations that traditionally took days of experimenting, rendering and retouching now are achieved at the computer in a matter of hours or even minutes.

The efficiency of computer graphics is apparent. However, the core of spatial understanding still lies with the artist's ability to visualize. The use of computer graphics does not guarantee good results. Successful and creative expression remains in the control of the artist who has a thorough understanding of the fundamentals of design, color and perspective.

Figure 79a and 79b

These images illustrate how an interior design student has utilized a three dimensional modeling application . The computer is used as a tool to explore the spacial relationships within a proposed commercial interior space. This is not to say that drawings were not made. In fact extensive plan view and perspective drawings were developed prior to the modeling of the space on the computer.

Figure 79c

This finished rendering of the space demonstrates the advantage of computer modeling over traditional approaches. A major change in view, color, texture or even lighting is simply a matter of minor changes in software settings and then the same model is again rendered. The modeling of such spaces however requires a thorough knowledge of the subject and a keen awareness of spacial organization. This knowledge can only come from an understanding of perspective drawing principles. The artist must also have the skills and ability to apply this understanding to explore the potential of the subject.

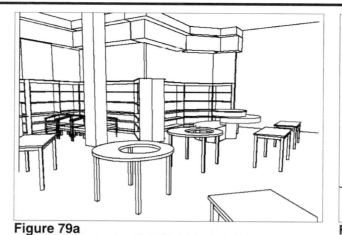

Figure 79a

Figure 79b

Figure 79c

Figure 80a

PORTFOLIO EXAMPLES
The applications of perspective can be found in virtually every aspect of art. On these pages are examples of drawings and illustrations from students, and professionals that represent the wide diversity of perspective applications.

Study the examples and analyze their perspective organization. Identify the type of perspective and locate the eye level and vanishing points. Notice how some of the perspective has been exaggerated for purposes of emphasis. This is particularly the case in the 360 degree view of the street scene shown on pages 80 and 81. This panoramic view is a good example of the many unique applications of perspective drawing principles.

Figure 81a

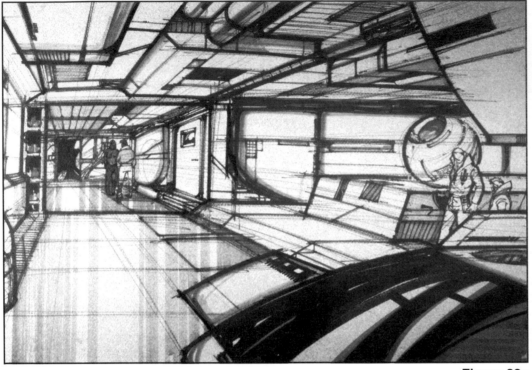

Figure 82a

SPACE SHUTTLE CONCEPT R.VANCE

Figure 82b

Figure 83a

Figure 83b

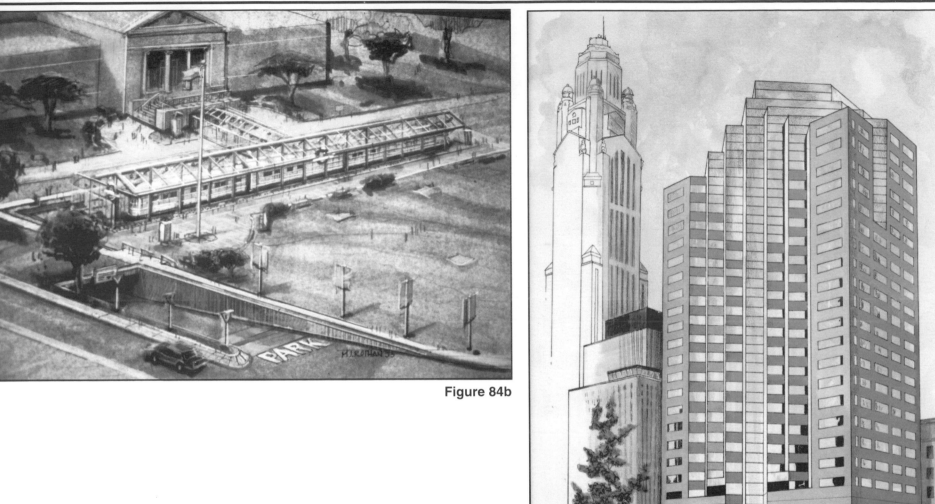

Figure 84b

Figure 84a

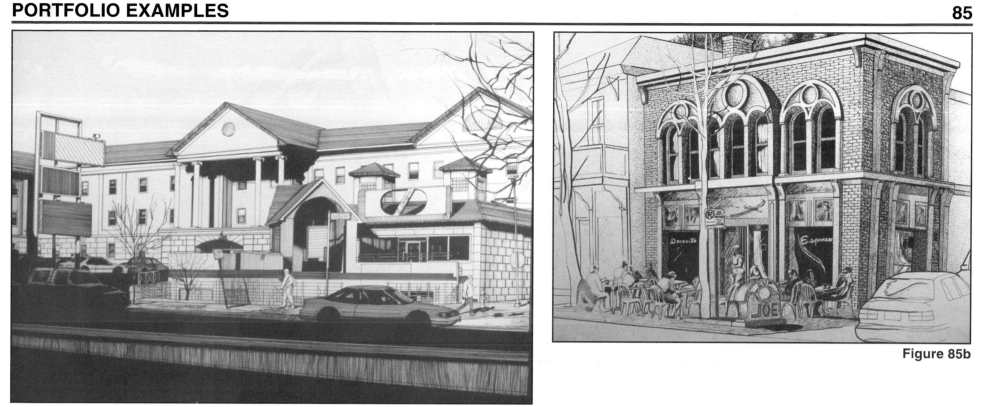

Figure 85a

Figure 85b

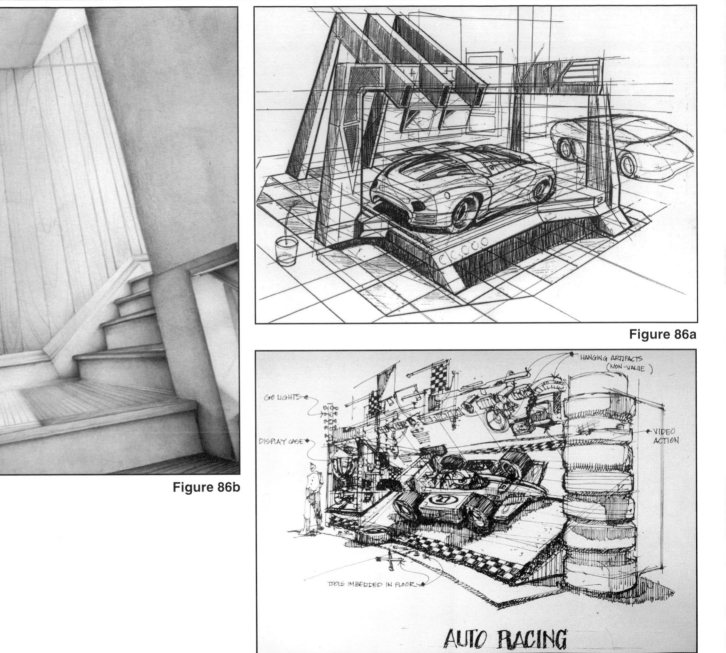

Figure 86a

Figure 86b

Figure 86c

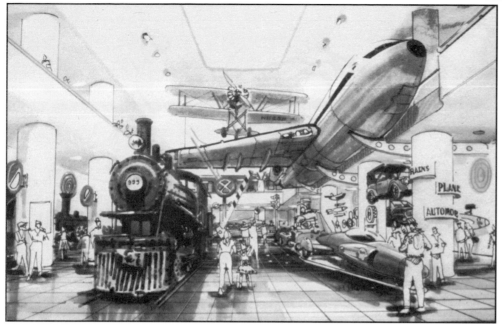

Figure 87a

Figure 87b

Figure 88a

Figure 88b

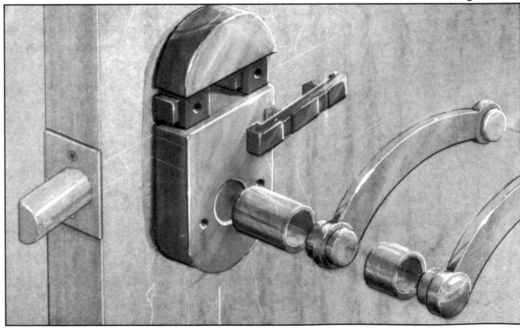

Figure 88c

Figure 89a

Figure 89b

Figure 90a

Figure 90b

Figure 90c

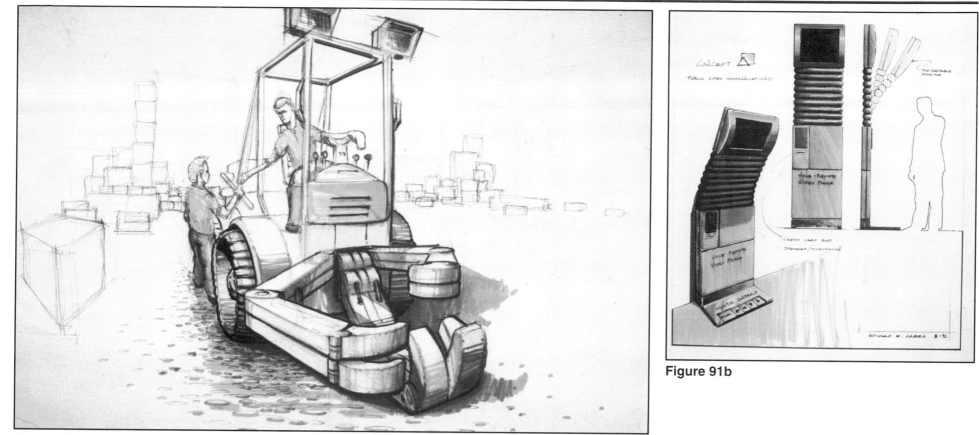

Figure 91a

Figure 91b

Figure 92a

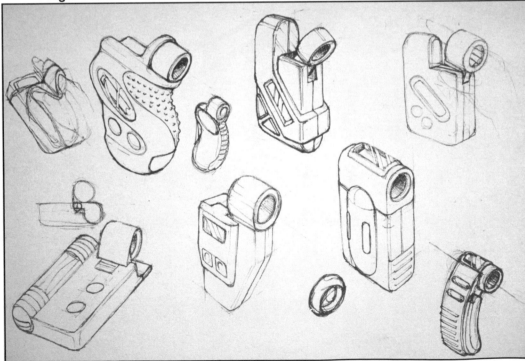

Figure 92b

Figure 92c

Figure 93a

Figure 93b

Figure 93c

AUTHOR	TITLE	PUBLISHER
Baartmans, Beverlly	INTRODUCTION TO 3-D SPATIAL VISUALIZATION	Prentice Hall, Inc. 1996
Ballinger, Louise	PERSPECTIVE SPACE AND DESIGN	Van Nostrand Reinhold 1969
Bishop, Minor L.	ARCHITECTURAL RENDERINGS	New York Architectural League 1965
Buckley, H.	PERSPECTIVE	London, Isaac Pitman & Sons, Ltd. 1947
Burnett, Calvin	OBJECTIVE DRAWING TECHNIQUES	Reinhold Publishing Corp. 1966
Cole, Rex Vicat	PERSPECTIVE	London, Sealey Service & Co., Ltd. 1936
Coombes, William	BACKGROUND TO PERSPECTIVE	Adam & Charles Black 1958
Doblin, Jay	PERSPECTIVE - A NEW SYSTEM FOR DESIGNERS	Whitney Publications, Inc. 1956
Escher, M. C.	THE GRAPHIC WORK OF M. C. ESCHER	Hawthorn Books, Inc. 1970
Gibson, James J.	PERCEPTION OF THE VISUAL WORLD	Houghton Mifflin 1950
Hanks & Belliston	DRAW!	William Kaufmann Inc. 1977
Hanks & Belliston	RAPID VIZ!	William Kaufmann Inc. 1980
Hogarth, Burne	DYNAMIC FIGURE DRAWING	Watson - Guptill Publications 1970
Jacoby, Helmut	NEW ARCHITECTURAL RENDERINGS	F. A. Praeger 1969
Kerlow, Isaac Victor	COMPUTER GRAPHICS FOR DESIGNERS AND ARTISTS	Van Nostrand Reinhold 1994
Lalli, V. P.	INTERMEDIATE PERSPECTIVE	Exposition 1959
Lawson, P. J.	PRACTICAL PERSPECTIVE DRAWING	McGraw - Hill Book Company, Inc. 1943
Lockard, W. K.	DRAWING AS A MEANS TO ARCHITECTURE	Van Nostrand Reinhold 1968
Martin, C. Leslie	DESIGN GRAPHICS	MacMillan Company 1968
Schaarwachter	PERSPECTIVE FOR ARCHITECTURE	F. A. Praeger 1964
Watson, E. W.	HOW TO USE CREATIVE PERSPECTIVE	Reinhold Book Company 1955
White, Gwen	PERSPECTIVE, A GUIDE FOR ARTISTS, ARCHITECTS, AND DESIGNERS	Watson - Guptill Publications 1968
White, John	THE BIRTH AND REBIRTH OF PICTORIAL SPACE	Harper & Row 1972

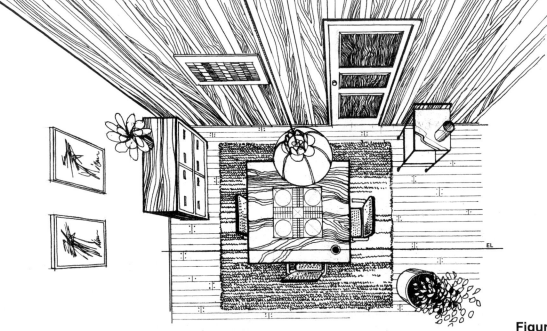

Figure 94a

Figure 94a

In this exaggerated interior drawing, the picture plane has been tipped until it is horizontal. The viewer is looking straight down. Whether the picture is in one or three point perspective is a matter of semantics. (Technically it is in three point.) The verticals are receding down toward vanishing point three, yet only one vanishing point is required for the drawing as the floor and all of the other horizontal surfaces are parallel to the picture plane. In this text the distinction between one, two and three point perspective is made only for instruction purposes. They are not separate subjects but interrelated. All of the procedures explained throughout the workbook are interrelated in a network of perspective concepts that are incorporated into the design process.

Figure 96a

3a:	Andy Ricard
4a:	M.C. Escher, "Relativity" 1953
	Escher Foundation, Haags Gemeentemuseum,
	The Hague
5a:	Marion Gatrell, "Corridor" 1965
	The Columbus Museum of Fine Arts
9a:	Albrecht Durer, "Perspective" 1525
13b:	CCAD Student Work
14a:	Childe Hassam, "Avenue of the Allies" 1918
	The Columbus Museum of Fine Arts
14b:	Julius Blum and Company, Inc.
14c:	United States Steel Corporation
16b:	Hans George Rauch
17b:	Amos G. Gott
18b:	N.L. Industries
23a:	CCAD Student Work
23b:	Arno Sternglass, MGM Television
23c:	Jan Vredeman de Vries, Dover Publications
24a,b:	Chute-Gerdeman Group
25c:	Erik Burdock
26f:	Fitch, Inc.
27b:	Fitch, Inc.
28a:	Friedrich Schonbach, GREFCO, Inc.
32a:	Pat Welch
32b:	Jan Vredeman de Vries, Dover Publications
37b:	Western Wood Products Association
38c:	Francis Satogata
40a:	CCAD Student Work
40b:	Joel Limes, Chute-Gerdeman Group
41b:	Jaime E. Yau
42a:	Tom Harmon
43b:	Janet Pathway
44a:	Omega, Norman M. Morris Corporation
46c:	Gary W. Fritts
48d:	CCAD Student Work
51a:	Joseph Collins
51b:	Priority Design
52a,b:	Priority Design
54a,b,c:	Burne Hogarth, "Dynamic Figure Drawing"
	Watson-Guptill Publications, New York
56e:	Randolph Ruzicka, "High Level Bridge #3" 1926
	The Columbus Museum of Fine Art
57f:	Michael Smith
61a:	Steven Phillips
62a:	M.C. Escher "Hand With Reflecting Globe" 1935
	Escher Foundation, Haags Gemeentemuseum,
	The Hague
62b:	CCAD Student Work

66c:	Eddy Stephens
75e:	M.C. Escher "Cubic Space Division" 1952
	Escher Foundation, Haags Gemeentemuseum,
	The Hague
79a,b,c:	Michelle Antholine
80a:	K. Bellis
81a:	K. Bellis
82a:	Paitoon Ratan
82b:	Rick Vance
83a:	Bob Welty, Chute-Gerdeman Group
83b:	Joel Limes, Chute-Gerdeman Group
84a:	Christopher Neal
84b:	Matt Rothan
85a:	CCAD Student Work
85b:	Jim Steffensmeier
86a:	Rick Vance
86b:	CCAD Student Work
86c:	Matt Rothan
87a:	Matt Rothan
87b:	Rick Vance
88a:	David Burghy
88b:	Matthew Myers
88c:	CCAD Student Work
89a:	CCAD Student Work
89b:	Matt Kaser
90a:	CCAD Student Work
90b:	David Burghy
90c:	Duff Swain
91a:	William Green
91b:	Edward Green
92a:	Ray Makowski
92b:	Brian Lawrence
92c:	Hsin Cheng Kuo
93a,b:	CCAD Student Work
93c:	Mark Mitchell
96a:	Dave Mankins, Beverage Management, Inc.
Cover:	Thomas J. Kier

Illustrations not listed above are by the authors.

Figure 82a

A little bit of perspective and a lot of imagination result in a humorous juxtaposition of scales in this three point perspective illustration. To emphasize the merits of the product, the pint bottle takes on the grandeur of the Empire State Building, King Kong was never happier! A unique blend of idea, composition and perspective application is the key to this and most other graphic successes. If Perspective can help with the control of the composition, then it is truly being used as a design tool.